IMAGES
of America

NORRISTOWN

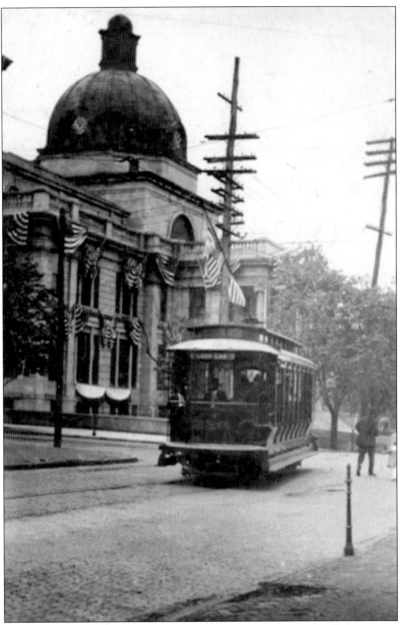

This photograph was taken in the spring of 1912 and shows a man with his young daughter getting off the open-air trolley at the corner of Swede and Airy Streets. Note that Swede Street is brick-lined and the hitching post to the right of the photograph. Hitching posts were a common sight in Norristown in 1912 as horses and wagons were still a main means of transportation. Passengers would have passed 12 restaurants in the borough at that time or one of the 16 hotels or 48 boot and shoe dealers or makers.

On the cover: Rocky Pignoli sticks his head out the door of his Sunoco Gas station in February 1960. The station was once located on Dekalb Street just off the Dekalb Street Bridge. The station was built in the early 1940s; Pignoli owned the station from 1959 through 1968. The station closed in the mid-1970s. (Rocky Pignoli.)

IMAGES
of America

NORRISTOWN

Michael A. Bono and Jack Coll

ARCADIA
PUBLISHING

Published by Arcadia Publishing
Charleston SC, Chicago IL, Portsmouth NH, San Francisco CA

Printed in the United States of America

Library of Congress Catalog Card Number: 2006936420

For all general information contact Arcadia Publishing at:
Telephone 843-853-2070
Fax 843-853-0044
E-mail sales@arcadiapublishing.com
For customer service and orders:
Toll-Free 1-888-313-2665

Visit us on the Internet at www.arcadiapublishing.com

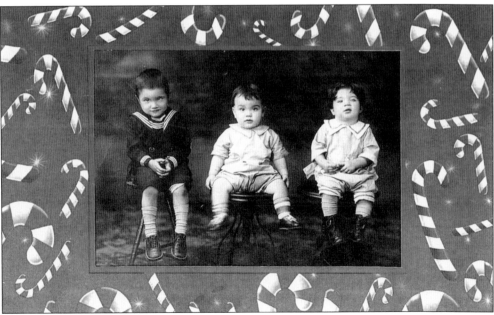

Three Norristown residents born in the 1920s who went on to become known as "Biggie," "Tank," and "Babe" were, from left to right, James LaSorda, Angelo Nicola, and Charles LaSorda, brother of James. Norristown was experiencing a population boom in the Roaring Twenties. This population explosion caused a ripple effect with the opening of new businesses that included 150 small grocery stores within the borough limits by 1925. (Phil LaSorda.)

CONTENTS

ACKNOWLEDGMENTS

While putting together the material for *Norristown*, the authors found it extremely interesting and gratifying to meet and talk to past and current residents of the borough of Norristown. Jack and Michael would like to thank the following individuals who have contributed greatly to the success of the story this book tells. When anyone starts to research a project in Montgomery County, they start and finish at the Historical Society of Montgomery County, located at 1654 Dekalb Street. Jeff McGranahan and the rest of the society staff are always happy to assist with research. The historical society can be reached at 610-272-0297 or online at www.hsmcpa.org.

Robby Cohen, Bill Landis, and Hank Cisco are the closest thing to a historical society outside the historical society. Landis has lived the history of Norristown through the lens of his camera as he snapped photographs and changes in the borough for nearly 50 years as a *Norristown Times Herald* photographer. And Cisco has lived the history and changes in the borough for more than 80 years as a policeman, and good will ambassador, contributing to every major cause in the borough.

It takes an army of interested individuals to fill these pages, so the authors would also like to thank Rocky Pignoli (great cover), Kathy Yost, Fran and Tony Cottonaro, Marjorie Rigg, and Aleks and Joel Eigen of Coffee Talk on West Marshall Street. Michael would especially like to thank his mentor, Joe Basile, for introducing him to Norristown history and the thrill of collecting Norristown artifacts. When looking for help with photographs, Dave Wingeron of Main Street Photo always has that professional touch.

Thanks to the following resources, writing the captions was a whole lot easier: the archives of the *Norristown Times Herald* newspaper, *Montgomery County: The First Hundred Years* and *Montgomery County: The Second Hundred Years* (both volumes can be purchased at the Historical Society of Montgomery County), Boyd's Directory, and a number of centennial, sesquicentennial, fire, and police publications.

Jack and Michael would also like to thank their wives, Donna Coll and Michelle Bono, for their time and effort. A final thank-you to everyone the authors did not mention (you know who you are), who contributed to the success of *Norristown*.

INTRODUCTION

When one looks back to the early 19th century, one cannot help but notice how raw life was and how advanced the borough of Norristown was. Before the dawn of the century, horse-pulled trolleys, and by 1893 electric trolleys, provided a transportation system. Shortly after, automobiles, mills, factories, and jobs for all the residents made the American dream a reality. By the 1950s, 1960s, and 1970s, the residents would first tell you about the Friday night shopping district, the wonderful movie houses, the hotels and restaurants, and the excitement of walking Main and Marshall Streets. And later they would tell how the town slowly died, the hotels, movie houses, and retail outlets mostly all gone.

Norristown was incorporated on March 31, 1812, just 17 miles northwest of Philadelphia; the town's population had reached more than 400 residents. The first meeting of town council was held on June 3, 1812, and Gen. Francis Swaine was elected the town's first burgess (mayor), a position he held for a year before Levi Pawling took over as the town's second burgess. The first order of business for the new town fathers was to adopt an ordinance restraining domestic animals from running free on the town's dirt streets. During the same council session, borough officials pushed for a tough ordinance to restrain young boys from throwing firecrackers in the street (it spooked the horses), the second ordinance pertaining to firecrackers was not enforced until after the Fourth of July in that first year of existence.

Proud families have continued to realize the American dream in Norristown as they opened businesses and worked in the borough for nearly 200 years. Thanks to the family members who took photographs and had the good state of mind to preserve these photographs that we share with you in this book.

The borough of Norristown thrived for more than 150 years with continued growth and economic boom. Then came the indoor shopping malls, and while Norristown had long been a major transportation center in Montgomery County and Philadelphia, the major highways seem to miss the borough. In the 1940s, the Pennsylvania Turnpike opened, and while there is a Norristown exit, the exit is in Plymouth Township and really nowhere near Norristown. In the 1950s, the Schuylkill Expressway opened to travelers like a gateway to the Philadelphia airport, sports complexes, and into New Jersey. But the expressway had no entrance or exit anywhere near Norristown. Then there was the blue route, 476, not in Norristown, and Route 422 expressway, also not in Norristown. The economic boom buster was the King of Prussia Plaza and Plymouth Meeting Malls, offering thousands of jobs, but neither was in Norristown.

At the beginning of the 21st century, Norristown has a bright future. Chain Mar Furniture, Zummo Hardware, Main Street Photo, Cycle Stop, and Bank's Café among other retail stores

are anchoring Main Street. The southeast regional offices of the Department of Environmental Protection now majestically rise from the corner of Main and Swede Streets, directly across the street from the county's courthouse. West Marshall Street is experiencing a rebirth in the retail district due to the vision and hard work of Dave Sereny, owner of DMS Properties. Fazio Realty Group has changed the skyline of Norristown with its development of upscale condominiums and is breathing new life into the borough with affordable housing. Several office buildings are being rehabilitated in the borough, and plans for condominiums and offices along the riverfront are in the blueprint stages. *Norristown* captures the borough at its best.

Jack Coll
Author

One

MAIN STREET AND
RETAIL OUTLETS

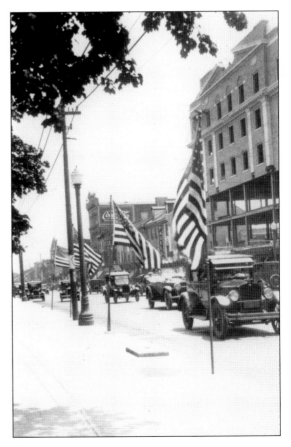

Cars pictured on East Main Street in 1925 approach Swede Street with the construction of the Valley Forge Hotel in the background. The new 80-room hotel replaced the former Montgomery House Hotel, but it was demolished nearly 50 years later in 1974. Pagels, a clothing store, can be seen in the center of the photograph. Pagels was on the site of the former Wards Oyster House, on Main Street at Strawberry Alley. (Historical Society of Montgomery County.)

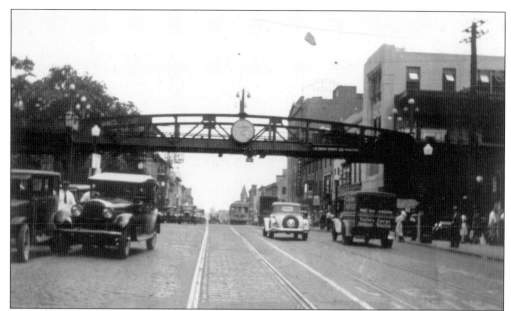

A rare look at Main Street in the mid-1930s shows the Philadelphia and Western (P&W) bridge crossing over Main street, where it traveled up Swede Street and went left on Airy Street. In the center of the photograph is a trolley car that was part of the old Citizens Company. The truck on the right is carrying Valley Forge Spring Water, and the buildings on the right are the P&W train station and the Valley Forge Hotel. (Historical Society of Montgomery County.)

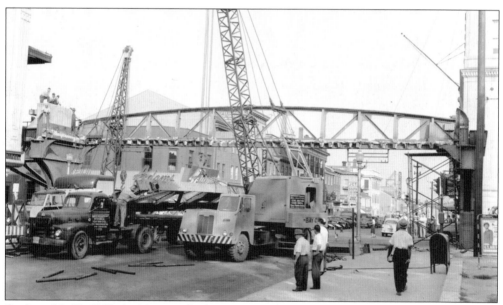

On June 28–30, 1955, the Mayer Pollock Construction Company of Pottstown disassembled the P&W railway bridge that spanned over Main Street for 43 years. The P&W trolley line that provided service from Sixty-ninth Street to Allentown was discontinued in the early 1950s. Norristown borough called for the bridge's removal to give shoppers and visitors an uninterrupted look up and down Main Street in an effort to give the business district a much-needed boost. (Bill Landis.)

Robert J. Snyder Jeweler, established in 1924 and once located at 12 East Main Street, had been a staple in the Norristown business district for more than 50 years. Snyder's was an upscale jeweler and gift shop attracting customers from throughout Montgomery County and beyond. Snyder's survived the Great Depression of the 1930s and enjoyed the shopping boom of the 1940s and 1950s. In 1950, Norristown had more than 650 retail outlets within the borough limits. At right is the very familiar Robert J. Snyder Jeweler storefront, and below is a view of the interior of the store. (Historical Society of Montgomery County.)

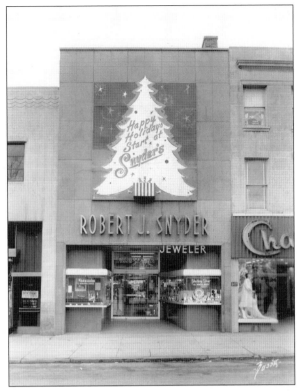

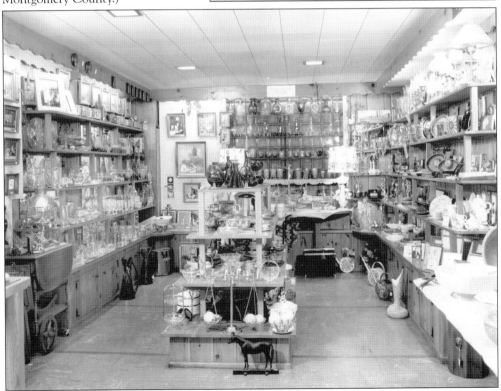

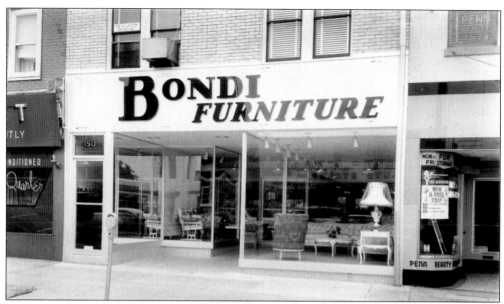

Bondi Furniture store, located at 150 West Main Street, is one of those feel-good stories as Bondi Furniture was established in 1926 and is still doing business today in the same location as when this photograph was taken in May 1957. While the storefront has changed, the fine furniture and excellent service has not. In 1957, Norristown's retail trade was at an all-time high with nearly 650 retail business in operation, helping to serve the 40,000 Norristown residents. (Bill Landis.)

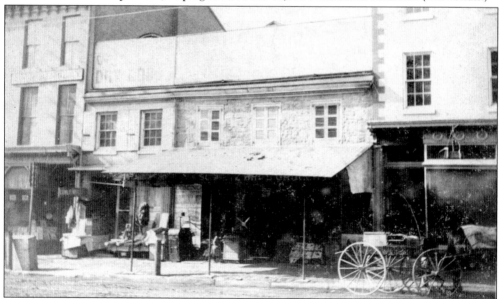

Moore and Ramey's General Store was located at 70–78 East Main Street, shown in this 1880s photograph. Retail stores became a necessity as immigrants poured into Norristown in the early 20th century to work in the mills. In 1892, Chatlin's Department Store opened for business in the 200 block of East Main Street; F. W. Woolworth's Five and Dime would soon replace Moore and Ramey's; Chatlin's closed its doors in the mid-1970s, more than 80 years after it opened; and Woolworth's closed its doors for good in the early 1990s. (Historical Society of Montgomery County.)

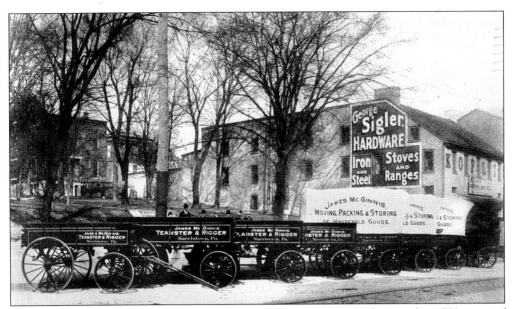

When the town of Norris was incorporated in 1812, the town had more than 500 acres of territory, and industry started a slow and steady growth along the Schuylkill River. By the 1890s, Norristown had 20,000 residents, and places of business like George Sigler's Hardware Store, Chatlin's Department Store (founded in 1892), and James McGinnis Moving and Packing Company were thriving. This early-1890s photograph taken along Main Street just below Swede Street shows the Norristown Public Square in the background.

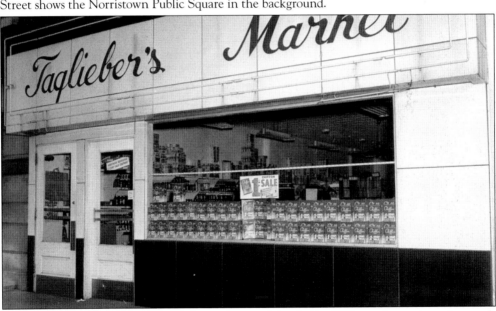

This photograph of Taglieber's Market, taken on March 11, 1949, was located on the south side of West Main Street. Taglieber's was established in 1918 and was having a 1¢ sale at the time of this photograph that included Hoffman Beverage's. Other items on the store shelf included Wheaties, Kix, and Kelloggs All Brand. In 1949, Norristown had more than 600 retail shops within the borough limits. Today Handsome Footwear Sporting Goods and the Z&W Laundromat occupy the site of the old Taglieber's. (Bill Landis.)

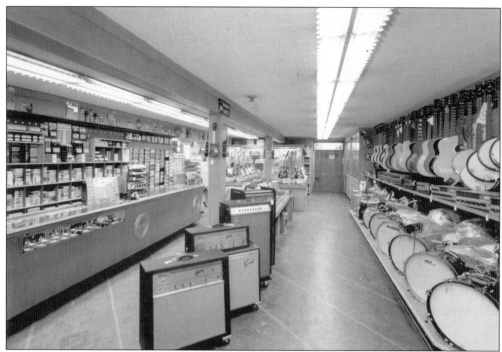

For many years, McCoy's of Norristown music store was located at 408 Dekalb Street. In the music store, McCoy's carried all the latest musical instruments and home appliances, stereos, and televisions. In the 1940s, 1950s, and 1960s, commerce was Montgomery County's biggest employer, and Norristown played a major role in those figures. In 1962, Norristown had more than 550 retail outlets within the borough limits including Sears Roebuck and Company, Block Brothers, Chatlin's Department Store, John's Bargain Store, Martin's, Grants, Spillanes, and Woolworth's. (Historical Society of Montgomery County.)

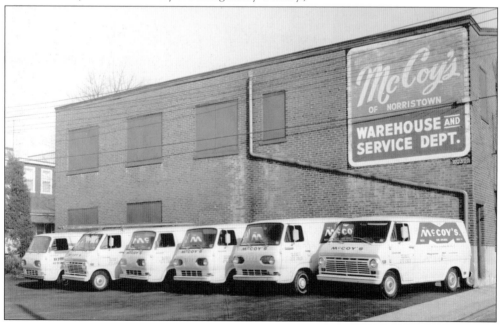

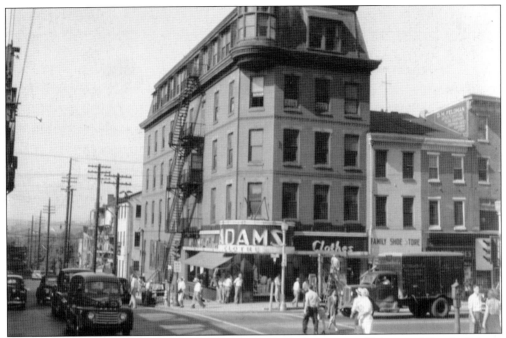

In November 1950, Adams Clothing Store, located on the corner of Main and Swede Streets, was the hub of Norristown's 550 retail shops along Main Street. Large department stores like Chatlin's Department Store, Sears, Blocks, Grants, Woolworth's, Spillanes, and Martin's attracted shoppers from throughout Montgomery County. In the 1890s, the building was known as the Times Building with its stately dome. In the 1890s, a lawyer named William Rennyson occupied the second floor, the third floor was used for vaudeville shows, and the top floor was occupied by the Beaver Tribe of Red Men. (Bill Landis.)

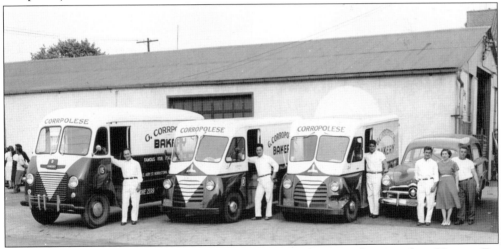

The Corropolese Bakery has been serving Norristown and vicinity for more than 50 years. For many of those years the bakery was located on East Airy Street, but this photograph was taken on Arch Street at the corner of Penn Street in front of the old Salvation Army building. The three drivers standing next to the truck, from left to right, are Carmen, Tony, and Joe Frangiosa. Leaning on the car to the right are Mike Frangiosa (left), a co-owner with Joe Corropolese (right), and his wife, Mary. (Lou Frangiosa.)

The old Birch Home, located on the corner of Airy and Dekalb Streets, was built in 1850 by William Jamison and occupied by his daughter Margaret from 1856 to 1906. Walter Yost later purchased the building as it looked in the top photograph, complete with the widow's walk on the roof, and transformed the building into a successful furniture, rug, and awning retail business. Notice that the front door was moved, windows were added, the side porch was enclosed, and in both photographs a gas streetlamp hangs from a cable over the Dekalb Street. The building today is occupied by Seiler and Drury Architecture. (The Yost family.)

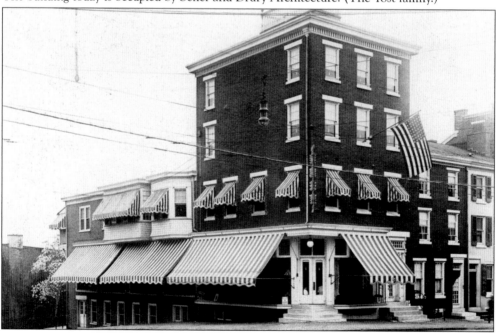

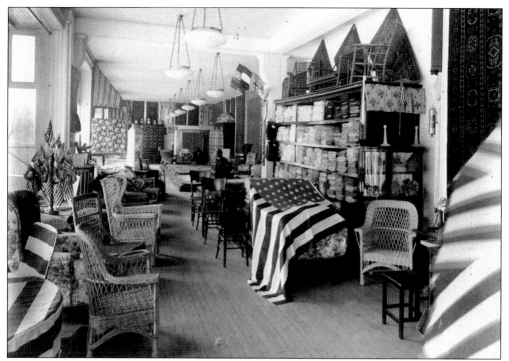

Walter Yost was the son of Daniel Yost, who established the D. M. Yost Store in 1862. Walter opened his own rug and awning store, once located on the corner of Dekalb and Airy Streets. These interior photographs of Walter's store show the furniture and rugs that were decorating homes in the late 1920s and early 1930s. Notice the wicker furniture and stacks of material lined on the store shelves. (Above, the Yost family; below, the Historical Society of Montgomery County.)

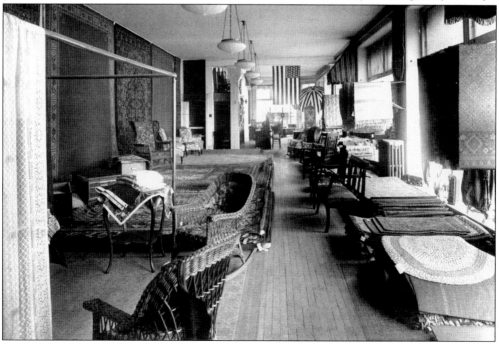

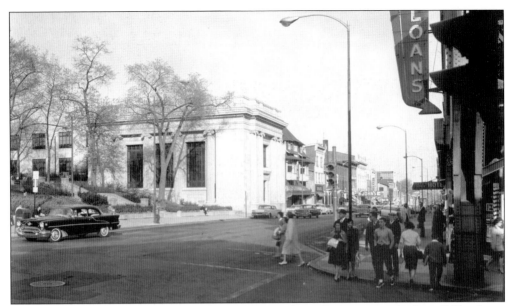

This photograph, taken from the corner of Main and Swede Streets in the late 1950s, shows the ABC Loans building, which also housed the P&W trolley transportation center. On the right is the sign for the Valley Forge Hotel. The public square is shown on the left, and the big white building is the Montgomery Trust Building. Ten years later, the Montgomery Trust Bank was demolished to make way for the county courthouse parking garage. (Historical Society of Montgomery County.)

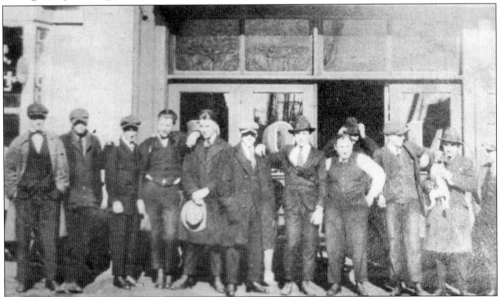

Cantello Pool Hall, once located at 219 East Main Street, was owned by Charlie Cantello, third from right in the photograph with the button-down vest. Cantello's was a popular meeting place in the 1930s when this photograph was taken. Although the clientele was mostly male, they would permit dogs from time to time, like the dog being held by the gentleman on the far right. Cantello passed away in 1940, and a pool hall era ended. Main Street Apparel now occupies the site. (John Charlie Smith.)

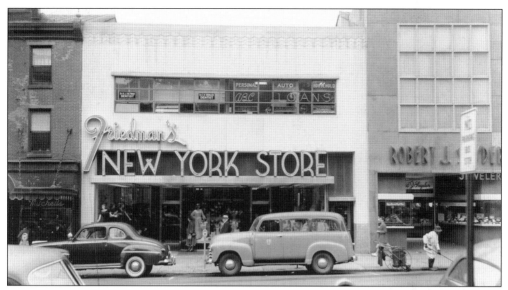

Friedman's New York Store once located at 16 East Main Street closed its doors in 1991 to make way for a Montgomery County Courthouse parking deck. This 1949 photograph shows the store that was established by Samuel Friedman, who sold household linens for decades. Mitchell's Clothing Store, to the left of the New York Store, was also demolished for the parking deck, while Robert J. Snyder Jeweler store became part of the Department of Environmental Protection Agency Southeast Regional Office. In 1949, Norristown had nearly 650 retail shops within the borough limits. (Bill Landis.)

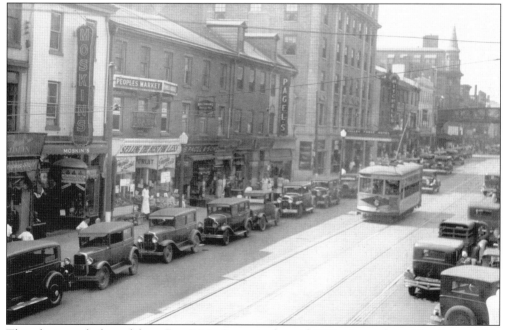

This photograph shows life on East Main Street in the mid-1930s. A number of the shops visible include Moskin's, Peoples Market, Pagels, and of course the Valley Forge Hotel. The Valley Forge Hotel was one of seven hotels in the mid-1930s listed within the borough limits. (Historical Society of Montgomery County.)

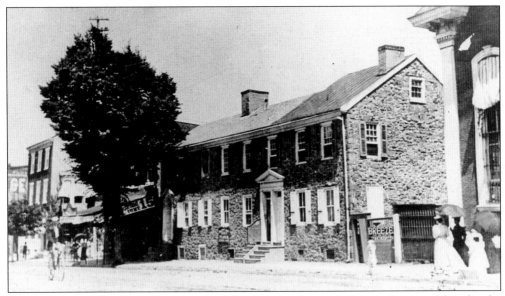

Pictured here is West Main Street in the 1870s. Notice the two ladies and young girl under the umbrellas to the right and the man on the bike to the left. The stone building in the center of the photograph was one of hundreds of retail outlets in the thriving community. The flour and feed shop sold farm and livestock supplies. The building was demolished around 1930 to make way for the Norris Theatre. (The Yost family.)

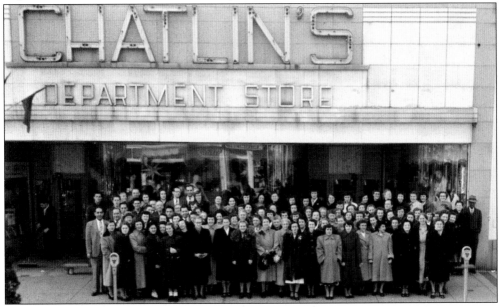

Chatlin's Department Store was one of the earliest true department stores in Montgomery County. The store was established in 1892 at 240–252 East Main Street and remained a staple in the county for more than 80 years. This photograph was taken of Chatlin's employees on December 24, 1949, just prior to opening for the Christmas Eve rush. In 1949, Norristown needed department stores like Chatlin's, as the borough's population had grown to nearly 40,000 residents. The borough had its own bus, trolley, and taxi service, and more than 12,000 automobiles were registered. (Bill Landis.)

The grand opening of Smith's Delicatessen, once located at 512 West Marshall Street, occurred in 1962. George Smith, on the left, and his wife share a minute with the minister of First Baptist Church and his wife. Smith's Delicatessen was located next to the former Norristown Penn Trust Bank. Smith's Deli was previously Hinkle's Deli and later became the site of Ward's Drug Store. (Tony Cottonaro.)

In the 1940s, Norristown was at its peak for the corner stores in the bustling neighborhoods. This 1940 photograph shows the corner luncheonette, once located at 600 West Marshall Street, which was one of 55 restaurants and lunchrooms in the borough, along with 110 grocers. Just beyond the candy store and the eyeglasses shop to the far right of the picture is the old Westmar Theatre with Pat O'Brien on the marquee starring in *The Fighting 69th*. (Tony Cottonaro.)

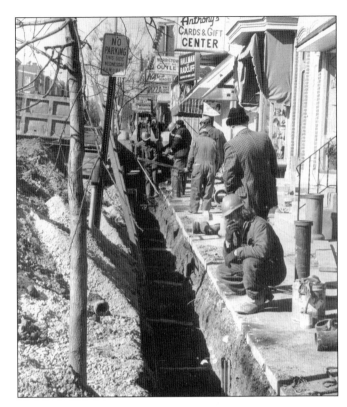

The 600 block of West Marshall Street was still a thriving retail section of Norristown in the 1960s when the street was being torn up to improve the gas and water mains. Visible stores on the right include Anthony's Cards and Gift Center; Hallman and Radcliff, very well known for its furnishings for the family; Norristown Outlet; a pizza shop; and a cleaners. Anthony Madonna owned the gift center and later opened Madonna's Music Store on Airy and Cherry Streets. (Coffee Talk Restaurant.)

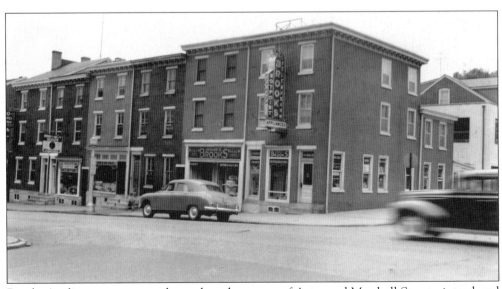

Brooks Appliances store, once located on the corner of Astor and Marshall Streets, introduced many of Norristown's residents to modern-day appliances. Brooks was one of the many retail stores located in the borough thriving in the postwar era. (Maryellen DiGrougo.)

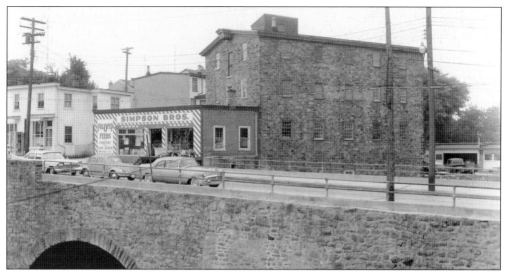

The old mill is one of Norristown's oldest buildings. Having survived a number of floods and dozens of owners, the building now stands as Taylor's Restaurant, a beautiful four-story eating and drinking facility. The restaurant was the Simpson Brothers Feed Company in August 1959, when this photograph was taken. The Simpson Brothers seed and feed store was established in August 1895 and had three generations of family ownership. The Simpson brothers were previously located on West Main Street before moving into the old gristmill in 1919. The old Oyster House Bar was still standing, seen in the left of the picture at 202 West Marshall Street. (Bill Landis.)

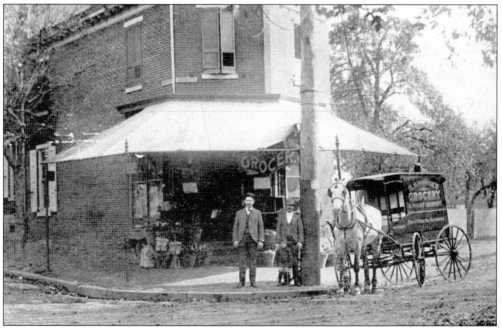

George E. Hallman, on left, poses outside his grocery store in 1890. The store was once located on the corner of Elm and Willow Streets in the north end of the borough. Hallman sold food, meat, hardware, and supplies. Hallman was happy to deliver the goods in his horse-drawn grocery wagon back before the beginning of the 20th century. (Historical Society of Montgomery County.)

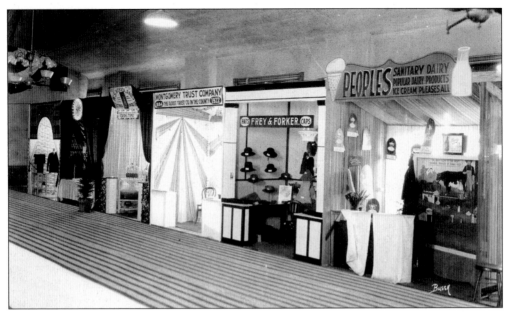

These 1922 photographs provide a rare interior view of the old farmers market located below Norristown City Hall, once located on the corner of Dekalb and Airy Streets. While it is unknown if the market was being used for some type of convention, a number of local businesses participated in the event. In the top left-hand corner is Kennedy's Stationery Store for the entire family, the second booth from the left is unknown, third from left is W. S. Woodland Electrical Contractor. The Montgomery Trust Company was represented, as was the Frey and Forker Hat Shop. Peoples dairy was one of several dairies located in Norristown in the mid-1920s. The lower photograph shows the beauty of the market with the *Norristown Times Herald* newspaper on the left along with Bake-Rite Bakery, and on the right is a nice display booth for the James Lees and Son Carpets from Bridgeport. (The Yost family.)

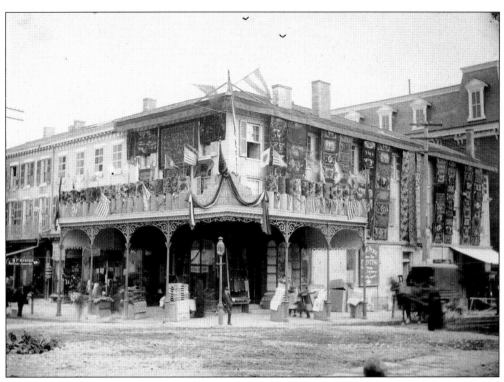

The D. M. Yost Dry Goods Store, founded in 1862, had a long and rich history in Norristown. The photograph above shows Yost celebrating 25 years of service to the community in 1887 in an unusual way, with rugs hanging from the roof and stacked up on the lower roof. Notice the young man leaning on the gas lamppost and the lady in motion to the right in front of the horse and wagon. At right is a picture taken at the entranceway into the store in 1875. Yost was a full-service department store selling goods from furniture to clothing. The business was passed down through the family until 1946 when Daniel Yost and his wife sold the store to Jacob Raboff, the one-time owner of the Sun-Ray Drug Stores. Even then the name of the business remained the D. M. Yost Company. (The Yost family.)

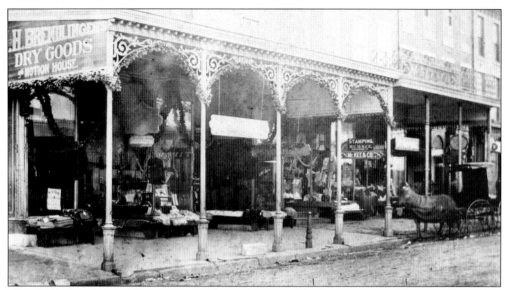

The I. H. Brendlinger Company was located at 80–82 Main Street and later expanded to 213 DeKalb Street. The I. H. Brendlinger Dry Goods business was established in 1870 and succeeded Neiman Brothers. In 1876, I. H. Brendlinger built a new store over the original store to expand his services. I. H. Brendlinger died in 1898, and Jay F. Brendlinger, head of the estate, continued to run the business well into the 20th century. The Brendlinger store sold dress goods, silks, domestics, ribbons, laces, gloves, and blankets, and sold the finest weaves of carpets, linoleums, oil cloths, and rugs.

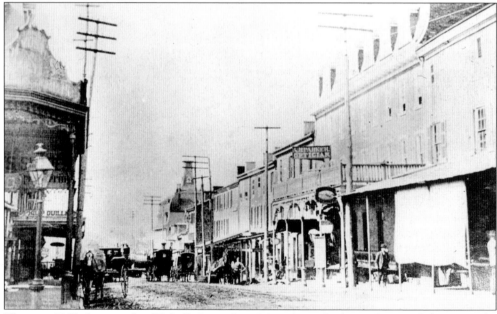

This rare 1865 photograph of Dekalb Street from Main Street looks south toward the river. The scene shows a busy retail district in the age of horse and carriages traveling along the dirt roads of the borough. On the far left of the picture just behind the gas lamp is the D. M. Yost store, established on April 12, 1862, by Daniel Yost. Just beyond the Yost store is Philip Quillman's store, and to the right is Parker's Optician. (The Yost family.)

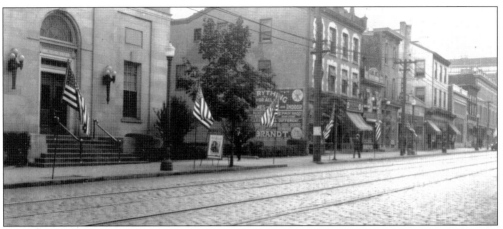

This 1915 photograph provides a glimpse of Main Street with the trolley tracks and cobblestone street. On the left, just behind the streetlamp, a corner of the post office can be seen. The post office has a history in the borough going back more than 150 years. Up until 1867, it was located in the corner of a store or tavern. The post office then had a room located in Odd Fellows Hall, and later a room in the Times Building located at Main and Swede Streets. But in 1906, the postal department erected a marble building at Main Street and Barbadoes Street, before building their current building on Airy Street in 1934. (Historical Society of Montgomery County.)

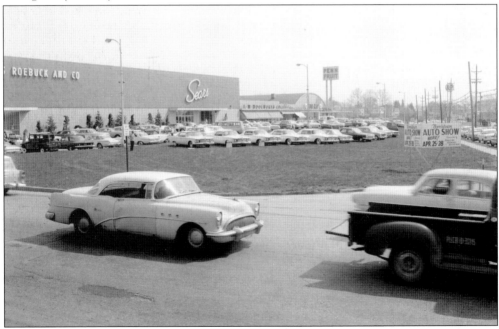

The Logan Square Shopping Center, located on Johnson Highway, was one of the first strip store complexes in Norristown, making it very attractive to shop away from Main and Marshall Streets. Shoppers found easy parking, air-conditioning, and more variety in one store than in two blocks of the traditional Main Street shopping. This early-1960s photograph shows Sears Roebuck and Company when it was on the lower level of the center, next door was the F. W. Woolworth's Five and Dime. The shopping center also had a Sun Ray Drug Store, Hamilton Savings and Loan Association, and Penn Fruit. (Historical Society of Montgomery County.)

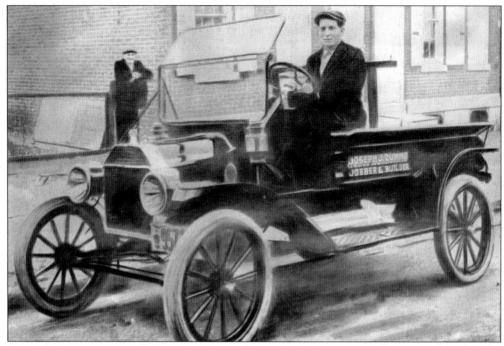

Joseph J. Zummo is sitting behind the wheel of his 1914 Ford truck when he was a jobber/builder in the early part of 20th century. Zummo is seen here on Moore Street with his father-in-law, Mr. Santangelo, looking on. Zummo purchased a hardware business from Mrs. Fredrick Gilbert in 1918. Mr. Gilbert opened the business at 259 East Main Street in the 1840s and worked the store until his death. Joseph Zummo purchased the business following World War I. In 1918, the Zummo family began working the Main Street Hardware business and continues working the business today with five family members carrying on the Zummo tradition. (Zummo's Hardware Store.)

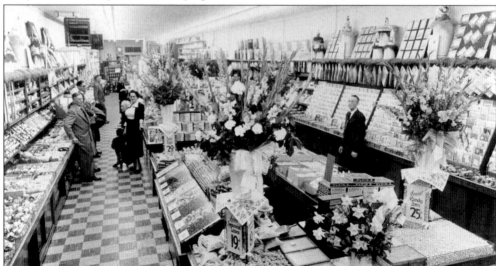

For decades all anyone had to say was "I'll meet you at Spillane's," and Norristown residents knew they were talking about going to 506 West Marshall Street, located in the center of the historical shopping district. Here is a rare look at the interior of the popular store celebrating a grand reopening after a fire closed the store in the early 1960s. (Tony Cottonaro.)

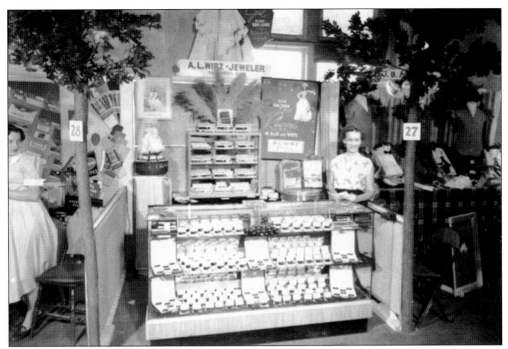

The A. L. Wirz Jewelry Store was one of many jewelry stores located in Norristown in 1948, when this photograph was taken at a display show held at the old City Hall Market. Wirz's store was located at 70 Penn Street. (Tony Cottonaro.)

While Myers Drug Store has been located at 328 Dekalb Street for more than 70 years (since 1935), the store dates back to the mid-1860s when William Camm opened the original drugstore across the street at 333 Dekalb Street. Camm later moved the business to 330 Dekalb Street and sold the store in 1890 to William Campbell. Arnold Armstrong Myers purchased the business in 1894 and changed the name to Myers Drug Store. In 1935, the business was sold to Morris Cohen, who in turn moved the business to its current location. Morris remodeled the interior of the store in June 1950, as seen in the photograph to the right, and the store has since been remodeled twice more. Robby Cohen continues to run the business. Myers Drug Store is the oldest continuously operating drugstore in Montgomery County. (Myers Drug Store.)

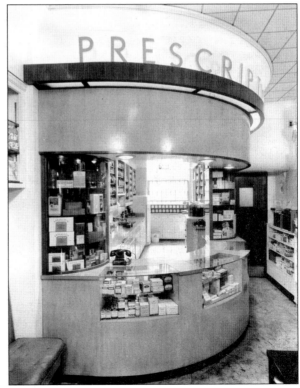

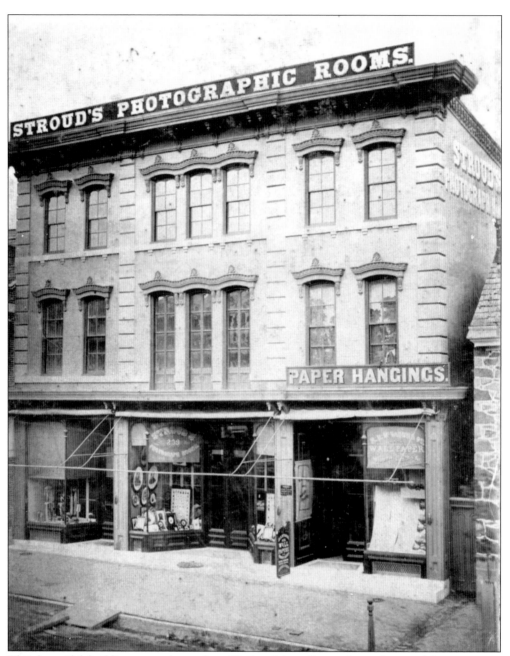

This beautiful building, once located at 59 East Main Street, housed several businesses in 1875, including Stroud's Photographic Rooms, Thomas O'Neill's Music Store, and selections of wallpaper. While Norristown still had dirt roads in the 1870s and the main means of transportation was still the horse and wagon, it was a thriving borough. Just to the left of the Stroud's Photographic building were the public square and the Montgomery County Courthouse. (Bill Landis.)

Two

FIRE, POLICE, AND SAFETY

Norristown has a long, rich history in firefighting dating from 1812 when the first volunteers stepped up to help build the borough's first firehouse at Main and Swede Streets. The original band of pioneer firefighters disbanded in the 1850s, but three other fire companies were chartered in the borough including the Norristown Fire Company, better known as the Norris, and the Montgomery Fire Company, both chartered in 1848. The Humane Fire Company, located at Main and Green Streets, was chartered in 1852, and in the photograph, a very enthusiastic crowd of borough residents can be seen at the Humane Firehouse dedication in 1887. Norristown has a total of five active firehouses within the borough limits. (Historical Society of Montgomery County.)

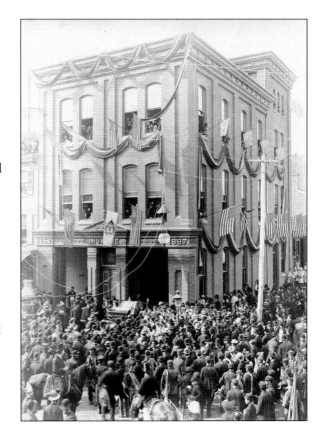

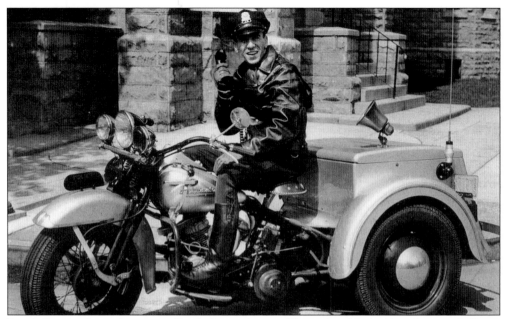

Frank Ciaccio, better known as Hank Cisco, shows off his police Harley Davidson in 1955 as a member of the Norristown Police Department motorcycle squad. Cisco served the Norristown Police Department for 24 years from 1951 to 1976. In 1955, Norristown had a 46-man department with eight pieces of motorized equipment including the motorcycle. Because of the wagon on the back of the motorcycle that carried safety equipment and other official police material, the motorcycle was called a "Popsicle wagon." (Hank Cisco.)

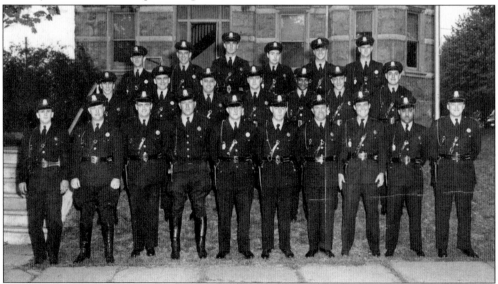

In the late 1950s, Norristown employed more than 50 full-time police officers, and the borough had a population of nearly 40,000 residents with close to four square miles to patrol. Policemen at that time throughout the country started to undergo extensive training for their jobs that included some of the latest technology for tracking and catching criminals like two-way radios, faster cars, finger printing, new weapons technology, and motorcycles. This photograph shows some of Norristown's finest attending the Federal Bureau of Investigation academy. (Hank Cisco.)

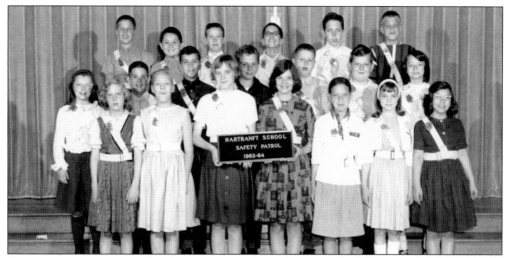

Students from the Hartranft School Safety Patrol pose for this 1964 photograph. The Hartranft School was located at the corner of Chain and Airy Streets. The original Hartranft School was built in 1894, across the street from the Chain Street School. Both schools were demolished in the early 1950s, and a new Hartranft School was built to handle the increase in population. Standing in the photograph are, from left to right, (front row) Margaret Shoemaker, Karen Errington, Jane Emey, Patricia Greco, Gertrude Bodge, June Jones, and Ledel Weber; (second row) Debbie Cole, Gordon McMeekin, Nicholas DeMeno, Walter Fracis, Keith Bartholomew, Ronald Sullivan, and Beth Spiegelhalder; (third row) Ronald Fulmer, Robert Neves, Keith Bean, Michael DeSante, Rodney Jones, and Robert Brannan. (Hank Cisco.)

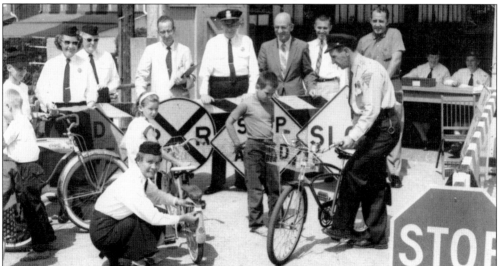

As bicycles became a main means of transportation for children in the 1950s and 1960s, it became necessary for local law enforcement agencies to inspect these bicycles for safety. In 1956, Norristown started a bicycle inspection program. This inspection took place in the spring of 1960 at the fourth annual bike safety inspection. Stooping down to place a sticker on the back fender of Diane Bondi's bike is school guide Ruth Doerner. To the right is Norristown police officer Hank Cisco inspecting a bike owned by Tom Beaver. Adults standing in the back looking on include, from left to right, Mary McKeever, Laura Holmes, George Owens, chief of police Robert Baxter, Leroy Lewis, Edwin Max, and Stan Wojusik. (Hank Cisco.)

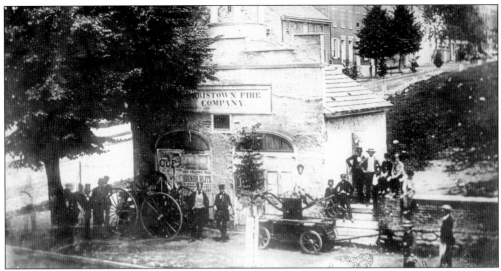

Norristown was incorporated as a borough with the stroke of Gov. Simon Snyder's pen on March 31, 1812. Within a month of incorporation, the borough fathers levied a tax, followed by a motion to purchase a fire wagon. The first firehouse was built in 1814, on the corner of Main and Swede Streets, seen here. Montgomery County officials gave permission to build the 12-foot-by-15-foot structure on what is now the public square. The county officials also contributed $150 in cash for the construction. The Pat Lyon hand-drawn water tank can be seen in this 1841 photograph, alongside a newer water tank purchased in 1827. Firemen in the photograph are identified as E. F. Solly, Benjamin F. Hancock (father of John Hancock), Robert Iredell, David Sower, Jacob Freedley, William H. Slinguff, James Hooven, and John Fleck, who is sitting on the engine.

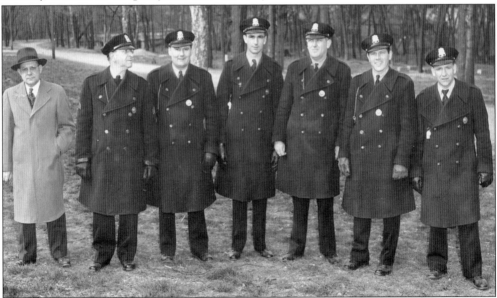

A number of Norristown's finest lined up for a mug shot in Elmwood Park in the early 1960s. It is interesting to note the dress of the officers with their button-down coats, white shirts, and ties, and notice the whistles hanging from each officer. Officers include, from left to right, Ron Bolton, the man in charge of parking meters; Sergeant O'Hara; Sgt. Edward Carigan; officer Francis Dougherty; Sgt. James Burns; and officers William Heidel and Jesse Scholl. (Hank Cisco.)

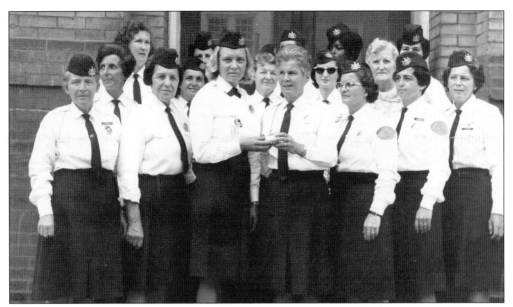

Crossing guards in Norristown have played a vital role in the safety of schoolchildren since the early 1950s. In 1947, a total of 9,000 passenger and commercial vehicles were registered in Norristown. A year later that number jumped to more than 13,000. By 1955, the Norristown Police Department employed six police crossing guards for schoolchildren. In 1957, that number jumped to 10, and when Hank Cisco became the town's safety officer the school, traffic guards swelled to more than 30. In the above 1960s photograph, the school traffic guards gather for a presentation, and below, Hank Cisco can be seen gathered with a number of the crossing guards at Jack Dempsey's Restaurant in New York. Cisco would go on yearly outings with the crossing guards to places like the Latin Casino in Cherry Hill, New Jersey, and different venues in New York. (Hank Cisco.)

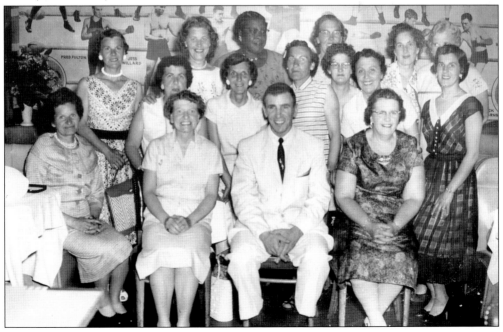

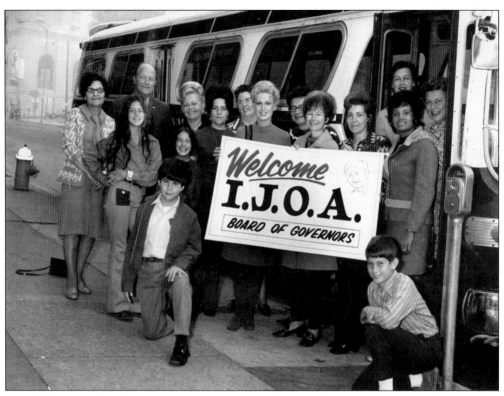

Members of the International Juvenile Officers Association pose in front of the bus in the early 1960s as they arrived for the yearly conference held at the Valley Forge Hotel located on Main Street in Norristown. In the photograph on the left, from left to right, are (first row) Mrs. John Murray, Mary Serifine, Dolores Cisco, and Mrs. Custer; (second row) Mrs. William Bambi, Mrs. Gelet, Dorothy Oberholtzer, and Mrs. Louis Prinzivalli. (Hank Cisco.)

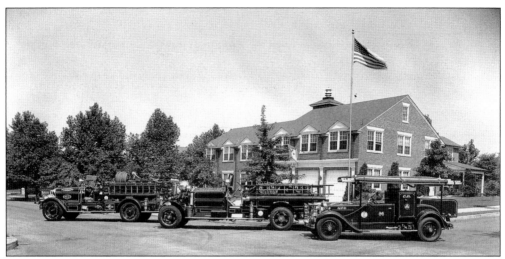

Incorporated in 1847, the Montgomery Fire Company is the second-oldest fire company in the borough. Located at Pine and Freedly Streets, the Montgomery remains one of the most active fire companies. Firefighting in Norristown goes back to 1812, just a few short months after the borough was incorporated. The first firehouse was located on the corner of Main and Swede Streets, on what is now the public square. (Thomas O'Donnell.)

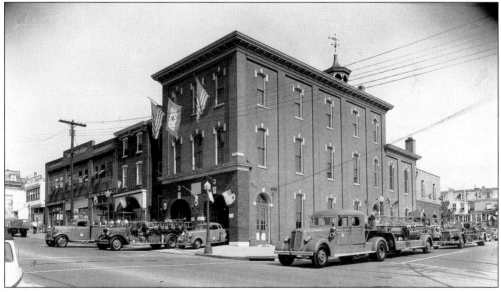

In the mid-1940s, the Fairmount Fire Company, located at Main and Astor Streets, was showing off its equipment, including a modern-day ladder truck. The Fairmount was chartered the same year as the Humane Fire Company in 1852 and is one of five fire companies within the borough limits. In the mid-1940s, Norristown was part of the postwar housing boom, the average new house in America cost $4,625, and a new 1945 automobile cost on average $1,025. Gasoline cost 15¢ per gallon. (Thomas O'Donnell.)

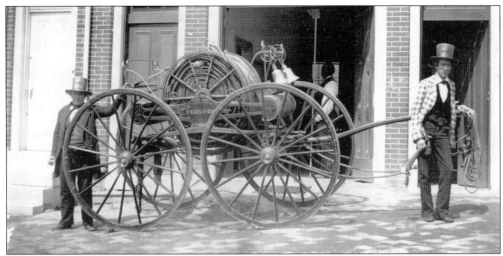

The Norristown Hose Company was chartered in 1848 and was one of two fire companies in Norristown at the time. Both companies pulled their apparatus by hand with a front man steering the wagon, and a "pusher," a fireman who pushed the wagon from behind. The Humane Fire Company, chartered in 1852, was the first to buy horses to pull their apparatus. By the mid-1880s, all three companies were using horse-drawn water and chemical wagons. This *c.* 1850 photograph shows John Bolton on the right with a horn in his hand and a top hat. Billy Beale is standing to the left behind the wagon and was commonly known as a pusher. Beale, a brush maker, was known to attend every fire in his day. Standing inside the door, Mr. Gibbs, the house cleaner, holds a brush on a pole. (Historical Society of Montgomery County.)

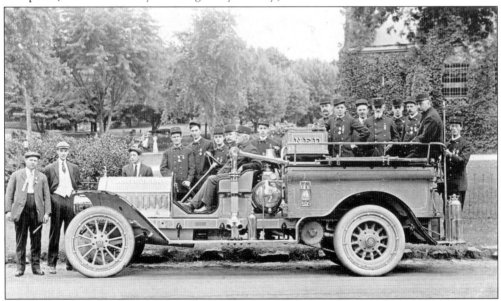

The Montgomery Fire Department was chartered in 1848, the same year as the Norristown Hose Company. By the 1880s, both companies were using horse-drawn hose carriages. The Montgomery Fire Department was the first company in Norristown to purchase a combination chemical and hose truck made by America La France, located in Elmira, New York. Members of the Montgomery Fire Company, dressed for a parade, show off the motorized fire vehicle. (Historical Society of Montgomery County.)

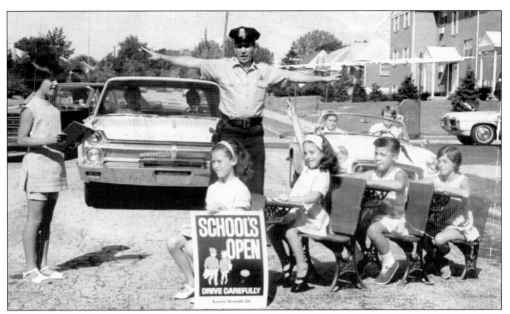

This back-to-school publicity photograph was taken in August 1968 and shows Sergeant Frank Ciaccio (Hank Cisco) holding up traffic with students sitting at their desk. Students, from left to right, include Patty Puccella, Linda Clark, Mary Laurie Ciaccio, Dawn Burrell, and Carol Lee Ciaccio. Seated in the foreign car in the background are Michael Donofrio and Dennis Cahill. (Hank Cisco.)

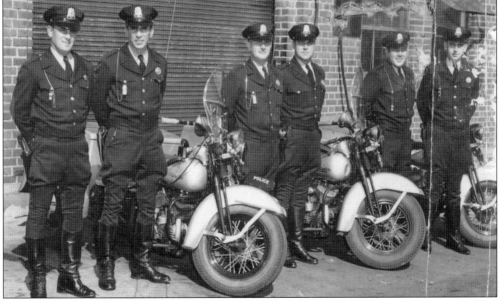

The Norristown Police Department added a motorcycle squad to the department in 1955. The squad was a specially trained department to primarily handle traffic control. By the mid-1950s the borough's population had grown to nearly 40,000 residents. Adding to the post war economic boom, nearly one in four residents had registered cars in the borough, hence the need for the motorcycle patrol. Standing with their motorcycles from left to right are officers Daniel Abate, Hank Cisco, Paul Smith, Dennis Tague, William Heidel, and Frederick Hill. (Hank Cisco.)

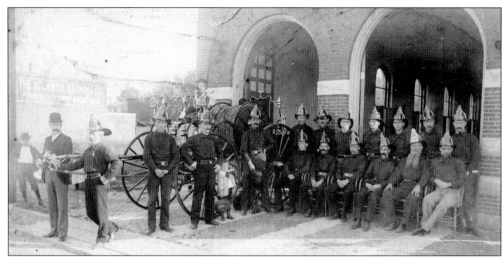

This 1885 photograph showing members of the Norristown Fire Company, located at Dekalb and Chestnut Streets, is typical of the borough's fire departments before 1900. The Norris firemen were showing off their horse-drawn fire apparatus. All of Norristown's fire apparatus was hand pulled until 1880, when the first horse-drawn wagon was purchased by the Humane Fire Company. From left to right are (seated) Jerry Delaney, Thomas Robinson, Joseph Hampton (the company president at the time), Alex Horn, fire chief Samuel Coats, and William Barber; (standing) two unidentified men, John Mullen, Henry Magill, A. K. Coats, Harry Peifer, Matt Kehoe, Robert Patton, Thomas Brophy, Patrick Skeridan, Howard Bickings, Richard Welsh, and Thomas Ridirigton. (Historical Society of Montgomery County.)

Members of the safety patrol from the Holy Savior School show off their trophies and certificates in the 1960s, when this picture was taken outside the Holy Savior School. Also included in the photograph on the left is Hank Cisco. Chief Robert Reilly, who joined the police force in 1924, is standing on the far right, and Pete Lewis is dressed in a suit in the second row to the right. Cisco worked with the borough's crossing guard unit and safety patrol for many years. (Hank Cisco.)

Norristown's first fire company was formed a month after the borough was incorporated in 1812. The Montgomery Fire Company was chartered in 1847 and called several locations home before settling into its current home at Pine and Freedly Streets. In the late 1920s, the Montgomery Fire Company owned a house on Penn Street, where driver Charles Campbell stayed. Campbell is seen in the photograph on the left talking to a police officer. (Carroll Campbell and Charles Picard.)

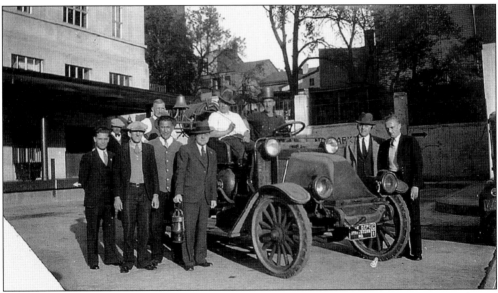

Montgomery Fire Company volunteers pose for a picture in the 1920s outside the firehouse once located on Penn Street. Charles Campbell, with the top hat, was the company driver. The Montgomery Fire Company organized in 1847 and is one of five fire companies in Norristown. (Carroll Campbell and Charles Picard.)

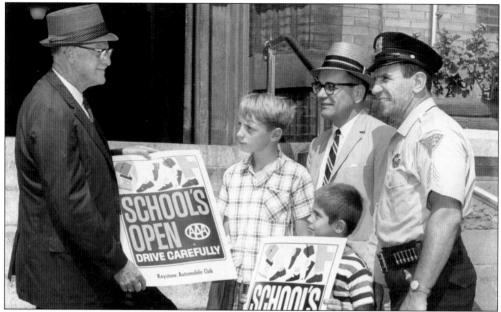

This photograph from August 1967 shows Chief of Police Robert Baxter on the left discussing the School's Open signs with students Robert Carey, then 13 years old, and Joseph Pasqueal, then 9 years old. On the right is Roy Hanshaw, Keystone's safety director, as the signs were sponsored by the Keystone Automobile Club, and Sgt. Frank Ciaccio, who was in charge of school safety projects. (Hank Cisco.)

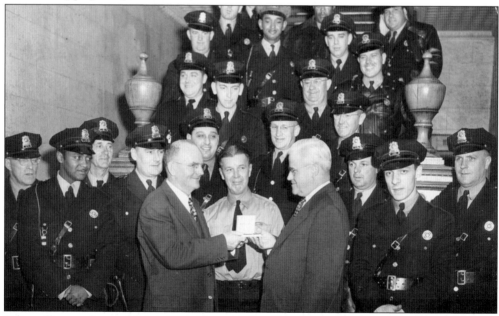

Police officers gather in this late 1950s photograph to honor retiring police officer detective Miller, on the right. Chief of Police Robert Riley, fifth from the left, presents detective Miller with a watch as Sgt. Edward Caragan looks on. Other officers in the photograph include Russel Carfagano Jr., Bob Weidman, Raymond Yates, William Heidel, Jack Fair, Fred Hill, Dennis Tague, Robert Furlong, Albert Parker, and officer Zigler, along with Sergeant Kingman. (Hank Cisco.)

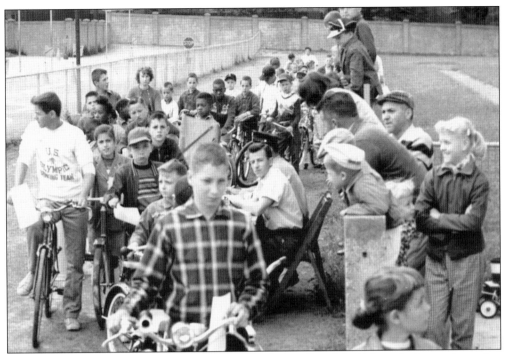

Every year the Norristown Police Department Safety Patrol held bicycle inspections that required children in the borough to get their bikes inspected and have safety stickers put on their bikes. Bike owners line up in the top photograph at the registration table at Roosevelt Field. In the lower photograph, the kids show off their trophies they won for their bike-handling skills. (Hank Cisco.)

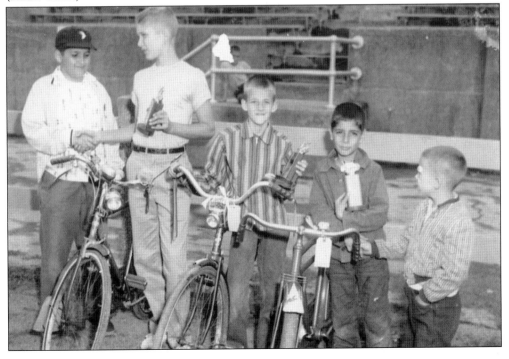

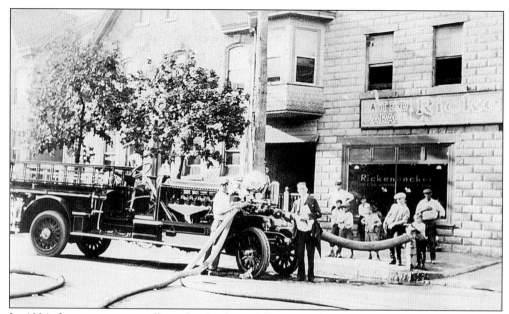

In 1924, fireman start to roll up the fire hose following a fire on the Ford Street Bridge that connected Norristown and Bridgeport. The fire came just two months after the Dekalb Street Bridge burned into the river. The Ford Street Bridge fire marked the first time Norristown was cut off from Bridgeport in over 100 years.

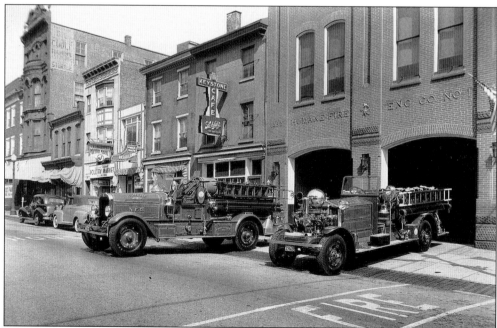

The Humane Fire Company is located at Main and Green Streets, and the building has witnessed the changes on Main Street for more than 100 years. Incorporated in 1852, the company dedicated its building in 1887 and has been in the same location since. Visible in this 1940s photograph is the old Keystone Cafe and Fisher's Poultry Market. (Thomas O'Donnell.)

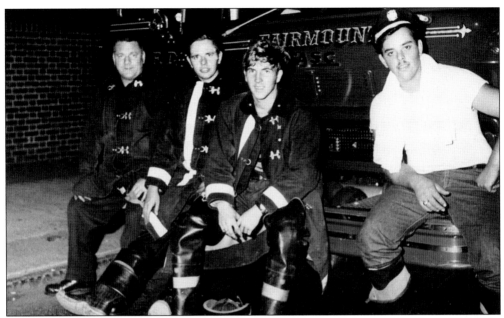

Four members of Fairmount Engine Company No. 2 take a well-deserved break in 1972, The members, from left to right, include Jack Wagner, Dave Freas, Ken Pierson, and Richard Stitler. In 1972, the Fairmount Company honored fireman Joseph E. Garner Jr., a lieutenant who was credited with saving the life of a four-year-old girl during a fire in her Norris Street home. (Hank Cisco.)

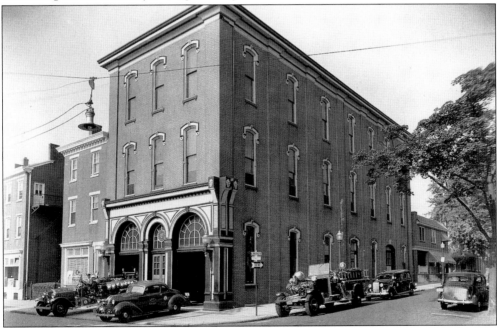

The Norristown Fire Company, located at the corner of Dekalb and Chestnut Streets, known as the Norris, has a long and proud history dating back to when the 11th president of the United States, James Knox Polk, who served from 1845 to 1849, was serving the country. During Polk's term as president, the Norris incorporated in 1847, making it the oldest incorporated firehouse in Norristown. (Thomas O'Donnell.)

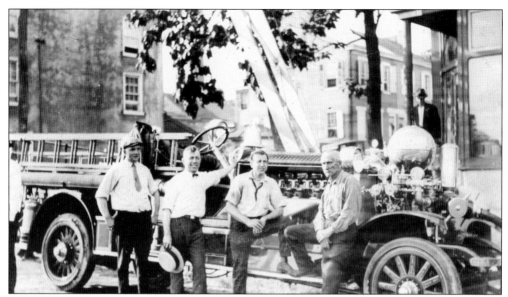

Members of the Montgomery Fire Company relax following two fires that struck on April 24, 1924. The first fire call went out for two house fires on Lafayette Street just above Cherry Street, at 3:30 p.m. Minutes later, another siren sounded for a fire that would burn down the Dekalb Street Bridge that connected Norristown and Bridgeport. Firemen fought the blaze from both ends of the bridge, but within minutes the entire span was engulfed in flames.

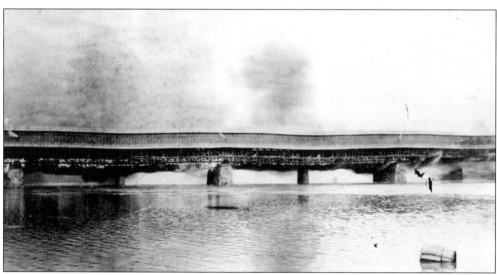

The Ford Street Bridge caught fire on July 10, 1924, cutting off all access between the boroughs of Norristown and Bridgeport. Patrick Coyle of Bridgeport was a motorist on the bridge when he discovered the fire and reported it to officer Early of the Norristown Police Department. Fairmount Fire Company firefighter John Lobb Jr. was killed, and two other firemen were injured while fighting the bridge fire. Lobb came from a family of firefighters, his father and three brothers were all lifetime members of the Washington Fire Company in Conshohocken.

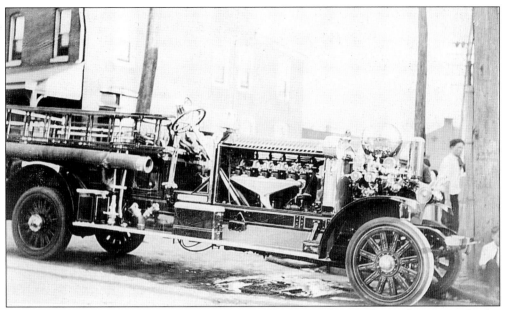

Fire trucks from the Fairmount Fire Company are seen here following the Ford Street Bridge fire that happened on June 10, 1924. It was estimated to cost more than $50,000 to repair the bridge, which was reopened two weeks later. One fireman was killed fighting the blaze, two others were injured. The bridge occupied a historic spot in the history of the United States. Gen. George Washington's army crossed the river on its way to Valley Forge on December 12, 1777, on a pontoon bridge.

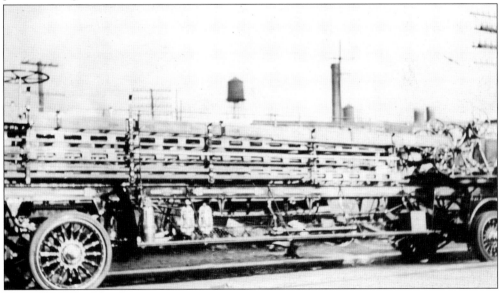

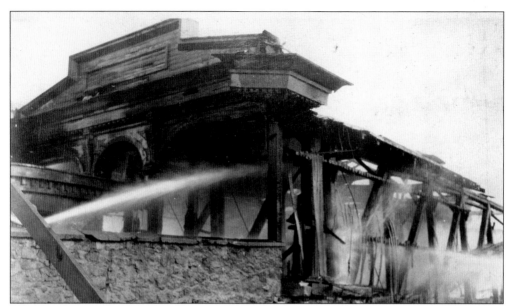

This photograph gives a bird's-eye view into what was once the entrance of the Dekalb Street Bridge. A massive fire broke out on April 14, 1924, and destroyed the structure. Citizens had cried out for a new bridge a year earlier when Montevill Vickery was killed in a horrible grade-crossing accident. Since July 16, 1923, local residents have pleaded for a new crossing connecting the two boroughs. The wooden covered bridge, built in 1829–1830 and rebuilt in 1861, was considered antiquated.

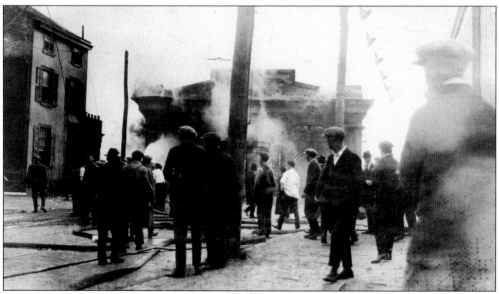

Spectators are seen wandering about this 1924 fire scene at the foot of Dekalb Street entering the covered bridge. On April 14, a fire that started in the center of the bridge quickly spread to both ends of the bridge within minutes. Gasoline and oil that stained the wooden surface of the bridge had been building up for years, and it did not take the fire long to burn it to the ground.

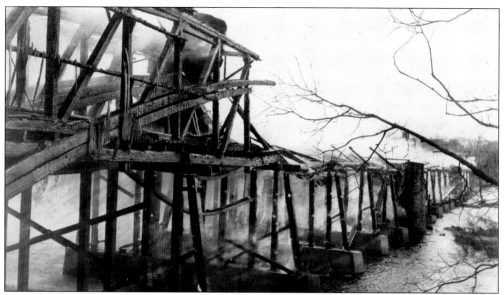

This was all that remained of the Dekalb Street Bridge following a fire that demolished it on April 14, 1924. Fire companies from Norristown, Bridgeport, Swedeland, and Upper Merion Township fought the blaze, but the flames spread much too quickly to save the bridge. Within a year, the county ordered a new concrete span that still serves the community. The bridge was once again rebuilt in the early 1990s but still has the same foundation.

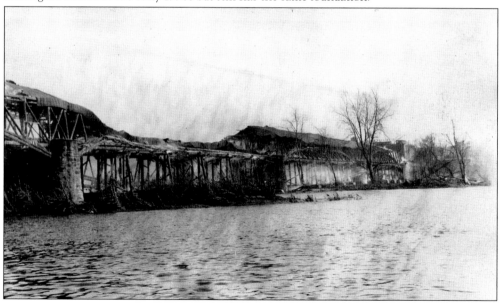

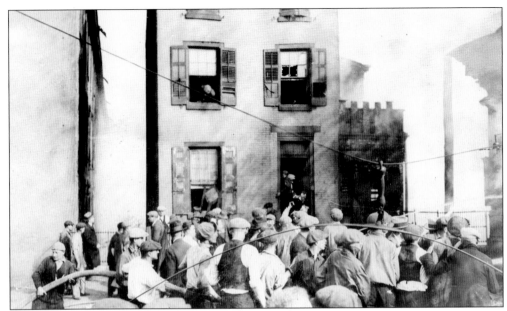

Firemen and residents are seen fighting the Dekalb Street Bridge fire. Residents who showed up minutes after the fire broke out quickly set about rescuing the household effects of Mrs. Hampton, caretaker of the bridge who resided at the Norristown entrance (seen above). James Cresson, Montgomery County fire marshal stated that the fire was not the work of a firebug in his opinion. It is believed that oil and gas that had leaked for years onto the wooden deck of the bridge were ignited when an automobile backfired, and the dry woodwork of the bridge was soon engulfed in flames.

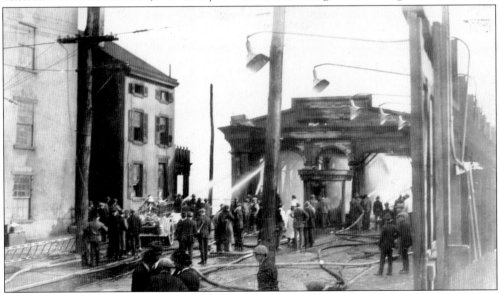

On Monday April 14, 1924, Norristown and Bridgeport firefighters fought one of the most devastating fires in the borough's history when the wooden Dekalb Street Bridge burned into the river. Once the bridge was lost, the firemen on both sides of the river turned their attention and water hoses to the nearby structures in an attempt to save them from the towering inferno. The covered bridge was erected in 1829–1830, was 800 feet long, and rested on three stone piers. The bridge was privately owned until the county took possession in 1884, making it a free bridge.

Three

TROLLEYS AND TRANSPORTATION

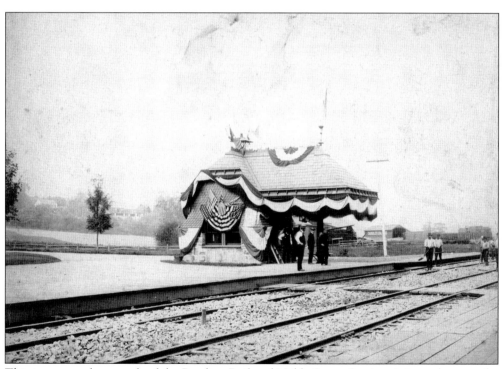

This is a great photograph of the Reading Railroad Noble Street Station. It is not known why the station was decorated with flags and patriotic colors, but it is known that two railroads were running through Norristown when this c. 1900 photograph was taken. The Reading Railroad, which was the former Philadelphia and Reading, and the Pennsylvania both provided much-needed service to area residents. (Historical Society of Montgomery County.)

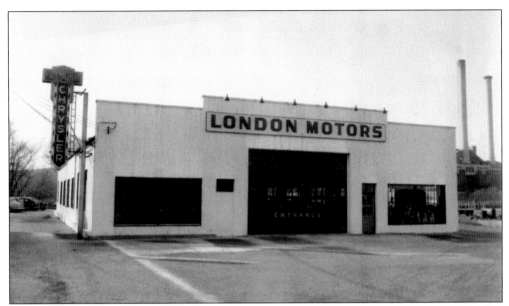

London Motors specialized in the Plymouth Chrysler motor vehicle in October 1948 when this photograph was taken. A. Allen London Chrysler Plymouth Sales and Service, seen here as London Motors, was located on the corner of Main and Markley Streets at 310–312 West Main Street. Car dealers were popping up everywhere in the borough during the 1940s and 1950s and for good reason considering the borough had more than 11,000 registered passenger automobiles and another 2,000 commercial vehicles. (Bill Landis.)

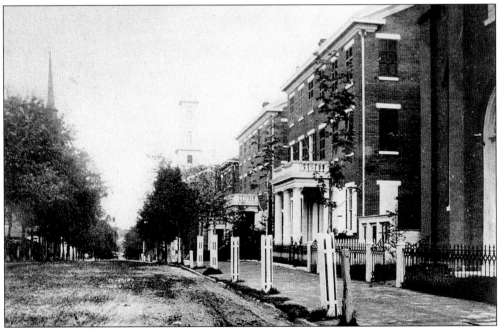

Norristown in the 1880s had dirt roads and hitching posts for tying up horses. This rare view showing Airy Street looking from Swede Street shows the private homes to the right that were later demolished for part of the courthouse. The post office was later constructed on Airy Street, replacing one of the buildings on the right side of the photograph.

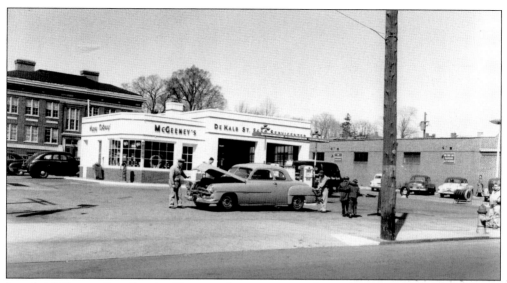

Joseph McGeeney Esso Service Center and gas station was located at 801 Dekalb Street on the corner of Oak Street. Happy Motoring was the Esso slogan, and this photograph taken on March 8, 1954, shows two service station attendants working the gas pump, one pumping gas while the other checks the oil. Notice the old Norristown High School located in the background. In 1916, the high school was named the A. D. Eisenhower School after the first high school principal in Norristown. (Bill Landis.)

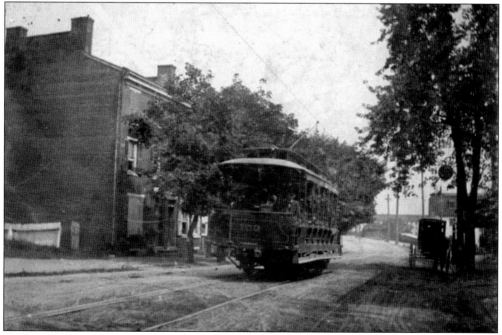

Trolley cars were the main means of transportation in the 1890s, and on July 19, 1893, the Schuylkill Valley Transit Company's system provided much-needed trolley service. In the photograph above, one of the early summer trolley cars can be seen traveling on Airy Street. The Schuylkill Valley Transit Company provided transportation for 40 years in the borough and ceased operation in 1933. (Joe Basile.)

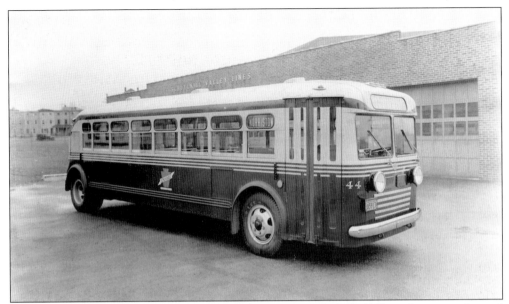

The Schuylkill Valley Bus Lines began operation on September 10, 1933, and was once located at 980 East Main Street. This photograph was taken in the early 1940s, before a gas station was erected next to the bus lines. In 1943, the average cost of a new house was $3,600. The average cost of a new car was $900, gasoline was 15¢ per gallon, and tuition to Harvard University was $420 annually. The Schuylkill Valley Bus Lines served nearly 70 boroughs and communities. By 1949, the bus line consisted of 120 miles of route.

On a winter's night in the early 1930s, this photograph was taken of the Norristown Ford Motor Company, then located at 638 Markley Street. In the 1930s, cars were becoming affordable to the average resident as the average price of a new automobile in 1933 was $550. In 1948, following the war, the average cost of a new automobile jumped to $1,230 and the borough of Norristown had nearly 11,000 cars registered in the borough. Today the building is home to Diamond Auto Glass. The lamps on the door are original.

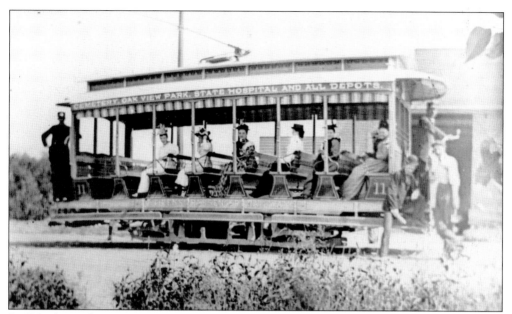

In 1884, horse-drawn cars running on Dekalb Street from Brown to Lafayette Streets were the borough's first public transportation system other than hired carriages. The Citizens Passenger Railroad was one such transportation system. By 1893, the first electric trolley cars hit Dekalb and Main Streets. The open-air trolley shown above ran a cemetery loop stopping at all the main points in the borough. (Historical Society of Montgomery County.)

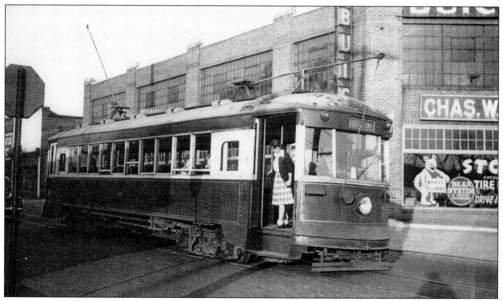

In the mid-1950s, most Americans owned automobiles, with the cost of a new car still under $2,000. But many Americans still depended on public transportation, including buses and trolleys. This young lady was stepping off a trolley at the corner of West Marshall and Markley Streets with the former Buick car dealership owned and operated by Charles W. Mann in the background. Residents would often use the trolley cars to shop at the major grocery stores like the Acme Markets, Penn Fruit, and the Atlantic and Pacific (A&P) Store.

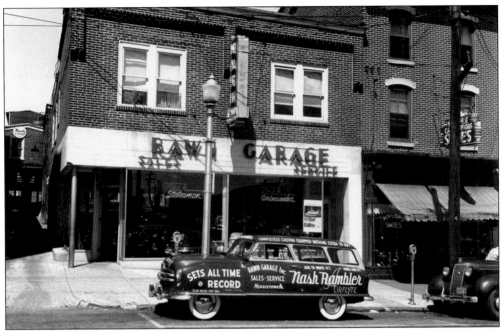

The Rawn Garage, once located at 209 East Main Street, specialized in sales and service for the Nash Rambler. In 1951, Norristown had dozens of car dealers in town and most were very successful considering the average cost of a new car was $1,520. Norristown also had 45 gas stations to help service cars more than 50 years ago. (Bill Landis.)

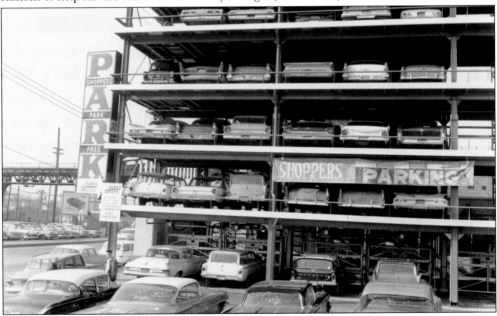

The late 1950s and early 1960s saw shoppers declining due to strip shopping centers and later the modern-day shopping mall. The borough was anxious to keep the retail merchants local and built a parking facility called the Pigeon Hole Parking Lot, on Lafayette Street behind the Valley Forge Hotel. The parking lot was troubled over the years with the mechanical device that loaded the cars onto a rotary-like elevator to transport the vehicles from floor to floor. (Bill Landis.)

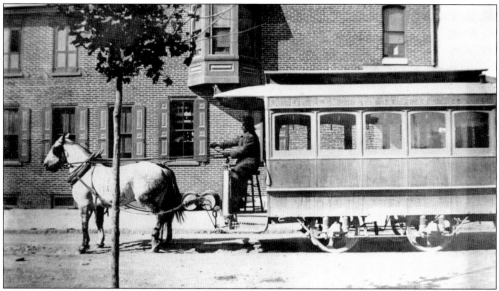

The first horse-drawn trolley car hit the streets of Norristown in 1884, with a route that included Main Street to Brown Street on to Dekalb Street, east on Main Street to Mill Street and down the latter street to the railroad station. The fare was 5¢ for adults and 3¢ for children. In 1887, a second trolley line was built on Main Street from Ford Street to the Montgomery Cemetery in the west end. This photograph shows the second trolley line. Both lines were short-lived as electric trolleys went in to service in 1893. On a Sunday afternoon in August 1899, the first horseless carriage was spotted by hundreds of residents. By 1901, there were 12 automobiles owned in Norristown.

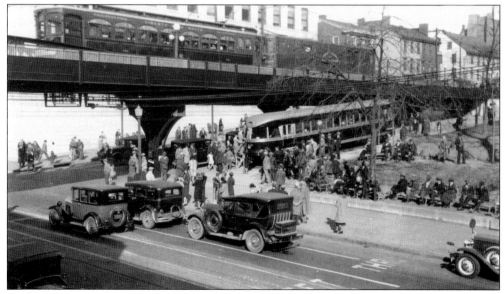

By the 1930s, Norristown was a thriving borough, a major shopping hub in Montgomery County, and a transportation mecca. The P&W trolley line is seen at the top of this photograph as residents inspect a new, sleeker model below, at the corner of Main and Swede Streets. The trolley line was extended out of Philadelphia to Norristown in 1911 and was later linked to Allentown. (Historical Society of Montgomery County.)

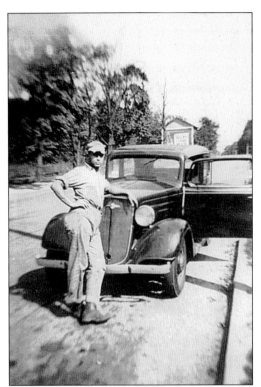

This 1930s photograph shows Pasquale Carfagno leaning on a 1933 Chevy out in front of 766 Sandy Street. The car belonged to Pasquale's father, Vincent, who built the house that the Carfagno family has lived in on Sandy Street for 85 years. (Russell Carfagno.)

This photograph, taken in June 1951, shows the Borss Chevrolet car showroom once located at 1230 East Main Street and 500 East Main Street. The cost of the average new Chevrolet in 1951 was $1,520, which certainly seems inexpensive by today's standards, however, the average income in 1951 was $3,515. (Bill Landis.)

This good-looking group was part of the Frangiosa Brothers Arco Station once located at 1100 East Main Street just across the street from the old Armen Cadillac Dealer. Frangiosa brothers owned and operated an Esso and Arco station for more than 35 years on Main Street before retiring in the mid-1980s. Included in the photograph are Mary O'Brien, Joe Valerio, Scott Marberger, and Lou, Dave, and Albert Frangiosa. (Lou Frangiosa.)

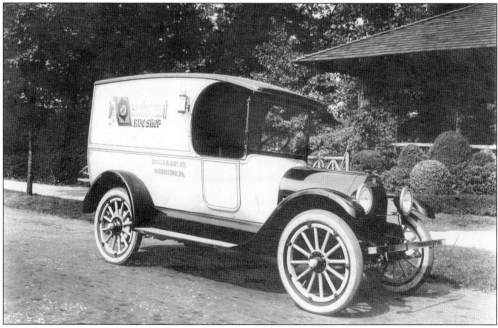

This was an early delivery truck for the Walter Yost Rug and Awning Shop. The store was located on the corner of Dekalb and Airy Streets. Walter was a brother of Dan Yost, whose father, Dan, established the D. M. Yost Department Store in 1862. Walter sold rugs, furniture, flags, and awnings. (The Yost family.)

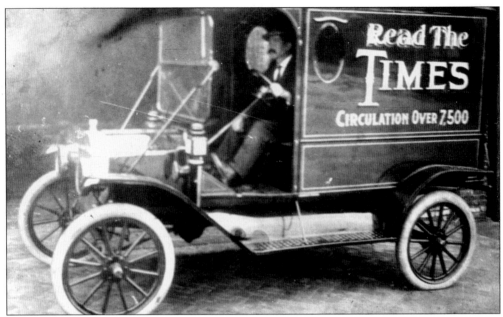

Newspapers in Norristown date from 1799 when Christopher Sauer founded the *Norristown Gazette*, a year later the paper was renamed the *Norristown Herald and Weekly*. A number of other papers came and went before Capt. William Rennyson of Bridgeport founded the *Norristown Daily Times* in 1881. In 1922, Ralph Beaver Strassburger combined the two newspapers as the *Times Herald*. Strassburger made many changes to the paper over the years and remained in control of the paper until his death in 1959. His wife retained ownership until her death in 1975, and Strassburger's son, Peter, became president of the Norristown Herald, Inc. The *Norristown Times Herald* is owned by the Journal Register and continues to print seven days a week out of their offices on Markley Street. (Historical Society of Montgomery County.)

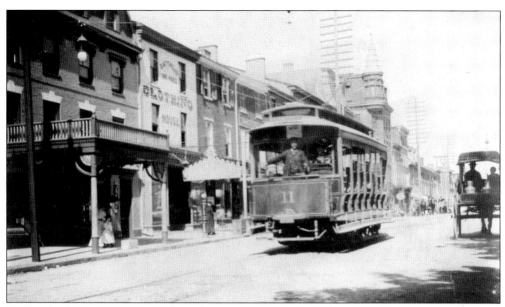

Trolley Car No. 11 is seen traveling along Main Street in the late 1890s on a beautiful summer day. Notice the pedestrians on the left of the photograph and the open-air summer trolley. Norristown's early trolley system started with horse-drawn trolleys in 1884. A decade later the electric trolleys came to town giving the residents the ability to travel throughout the borough. The electric trolleys began running in 1893 and ran for 40 years. The final trolley rode the rails on September 9, 1933.

The Sunoco Gas station was located on Dekalb Street just off the Dekalb Street Bridge. This 1963 photograph shows regular gas was 28¢ per gallon and the station was an official Hertz Rent-a-Car center. The Sunoco was owned by Rocky Pignoli, who owned the station from 1959 to 1968. The station closed in the mid-1970s after more than 35 years of service to the community. (Rocky Pignoli.)

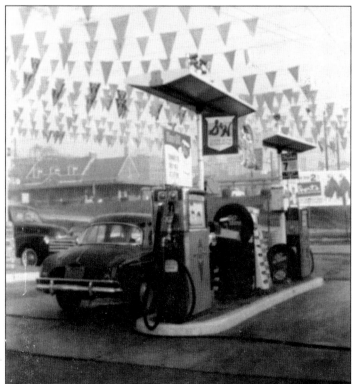

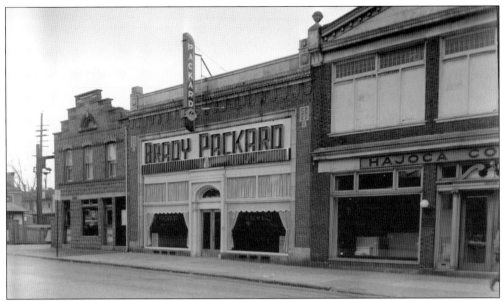

The first horseless carriage drove through Norristown in 1899, and shortly after, automobile dealerships started popping up. Brady Packard, located at 310–312 West Main Street (the current site of Euro Marble and Granite), was one of dozens of car dealers of the day. Shortly after this photograph was taken, a Ford dealership moved in next door, at 314 Main Street. Notice the small train crossing guard house on the far left; every time a train approached the intersection, a guard would come out of the house and stop traffic until the train crossed. (Bill Landis.)

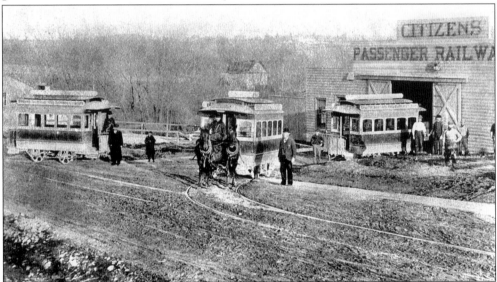

This rare photograph shows the terminal of the Citizens Passenger Railway, once located on the corner of Brown and Willow Streets. The railway was established in 1884 and was the first horsecar line in the borough. The horse-drawn trolley line ran from Main Street to Brown Street on to Dekalb Street, east on Main Street to Mill Street, and down Mill Street to the train station. The original fare was 5¢ per adult and 3¢ for children. A second horse-drawn trolley company opened up for business in 1887, but both companies were short-lived as the electric trolley cars were established in 1893.

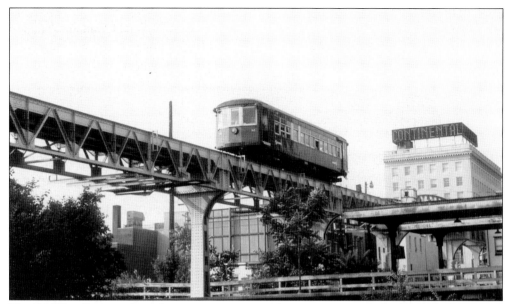

The P&W trolley cars have been a main means of transportation in the borough since 1911. The trolley line connects Norristown to Sixty-ninth Street in Upper Darby. When the P&W trolley line was built to span the Schuylkill River in 1911, it was declared a modern marvel. A station was built at the Norristown end of the line in 1911, a new station was built in 1931 at a cost of $65,000, and a more modern version was built in the 1990s at a cost of millions. This photograph was taken in the late 1960s.

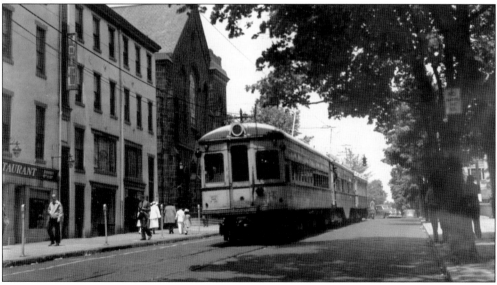

The trolley, seen here on May 14, 1950, on Swede Street was part of the P&W line, owned by Lehigh Valley Traction. The trolley company operated a high-speed passenger line and could get passenger cars from the Sixty-ninth Street terminal in Upper Darby to Allentown in as little as an hour and 40 minutes, which was considered extremely fast. To the left was the Rambo House Hotel, established in 1855. Next to the Rambo House was the First Baptist Church, established in 1832 with services at the courthouse. This church was built in 1834 on the corner of Airy and Swede Streets.

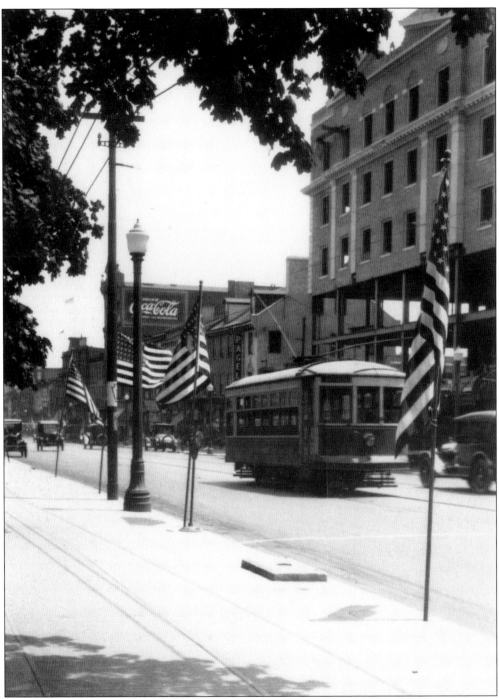

In 1925, Norristown was 113 years old and the pride of Montgomery County. Electric trolley car service replaced the old Citizens horse-drawn trolley service in 1893, and electric trolleys ran Main Street until 1933. The electric trolley is shown on East Main Street outside the Valley Forge Hotel in 1925, while the hotel was under construction. (Historical Society of Montgomery County.)

Four

FLOODS

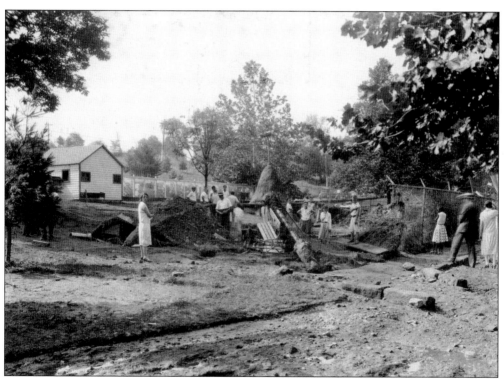

A heavy storm hit Norristown on July 9, 1931, causing severe flooding throughout the borough including at the Elmwood Park Zoo. Residents and borough officials are seen at the zoo the day after the floodwaters receded. While there was widespread damage throughout the borough, the flood at the zoo posed another type of problem. Zookeepers reported that six alligators swam away during the flood and were residing somewhere in the borough, looking for food. Four were captured a few days after the flood, but the final two, including one alligator measuring over six feet, were not captured until a week later when they were found by the old trim Beidler miniature golf course not far from the Armory building. (Historical Society of Montgomery County.)

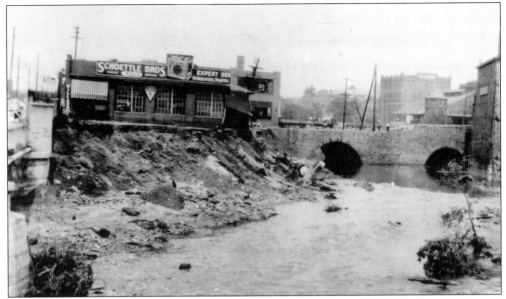

This was the aftermath of one of the borough's worst floods in nearly 200 years, this view of Stoney Creek shows the banks of the creek washed away. Hundreds of businesses and households were affected by the loss of electricity and running water. Business like Charles W. Mann, Herberts Hosiery Mill, Norristown Rug Company, Keystone Automobile Agency, Adam Scheidt Brewing Company, and the Paine Motor Company were just a few of the businesses brought to a halt.

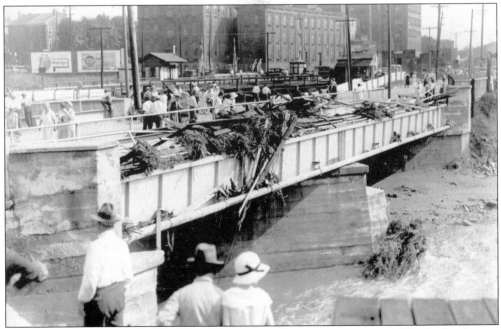

Norristown residents and onlookers get a first-hand view of the damages caused by the floodwaters along Markley Street on July 10, 1931. The flash flood caused millions of dollars in damages to the borough, and one resident drowned in the flood. The W. K. Gresh and Sons Cigar Factory can be seen in the background on West Marshall Street. (Historical Society of Montgomery County.)

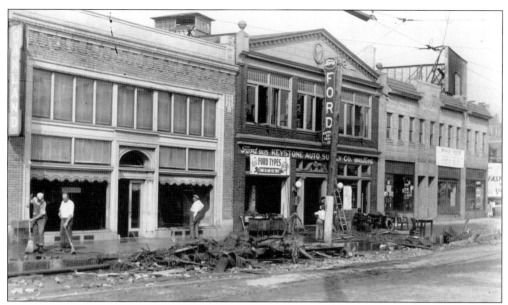

On a hot July night in 1931, a violent thunderstorm unloaded in Norristown just before midnight, and the results would cost home owners and business owners millions of dollars in repairs. Business owners, seen here on the 300 block of West Main Street, assess the damages and start the clean-up process. The building on the left still stands today at 310–312 West Main Street and currently is the Euro Marble Granite Company. The center building was a Ford Motor Company automobile supply outlet. (Historical Society of Montgomery County.)

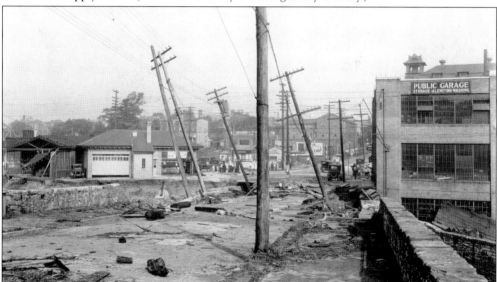

Flood-ravaged East Marshall Street was the scene of this photograph following the July 9, 1931, flood that killed one resident and cost taxpayers and businesses millions of dollars to clean up. The late-night storm that crippled the area from Valley Forge Park to Norristown was unlike any storm in the past 100 years. The building on the right with the public garage sign was later part of the Charles Mann Buick Motor Company on the corner of Markley and Marshall Streets. Thousands of people flocked to Norristown to see the flood-damaged area, causing major traffic problems. (Historical Society of Montgomery County.)

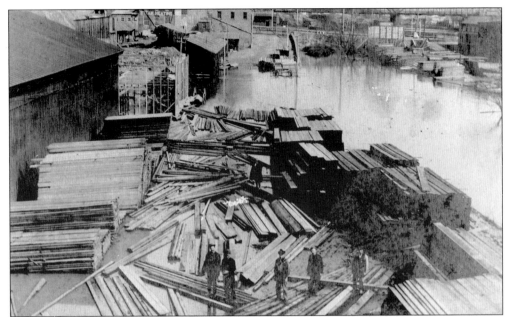

This is an amazing view of the flood-ravaged area along the Stoney Creek in 1902 as workers at the Grater-Bodey lumberyard prepare to start cleaning up the result of the flood. In 1902, a late-night thunderstorm hit the borough without warning, causing millions of dollars in damage and costing one resident his life. It took the borough more than a year to recover from the flood. (Historical Society of Montgomery County.)

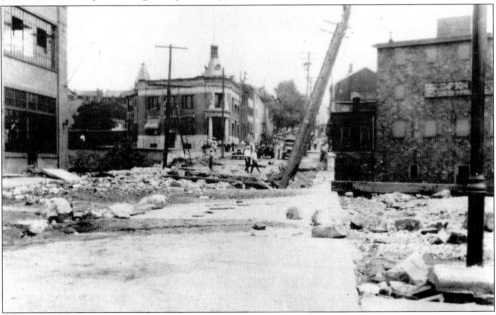

This was the scene along East Marshall Street following the worst flood in the borough's long, rich history. On July 13, 1931, a terrific rain storm hit the borough, causing more than a million dollars in damage. The bridge spanning Stoney Creek at Marshall Street was destroyed by the flood. Thousands of visitors flocked to the borough on July 14, 1931, to view the damage to the streets and building.

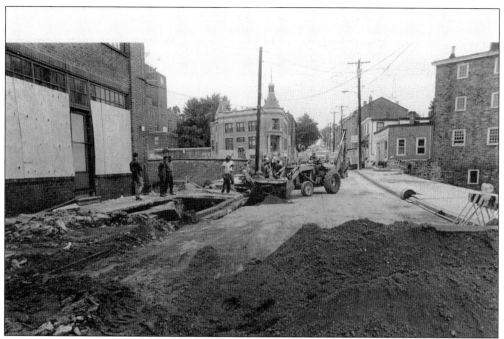

Floods along the Schuylkill River have been recorded in the Norristown area going back to 1757. Stoney Creek, which runs alongside Markley Street, has also been the source of uncontrollable flooding throughout the years, as seen in these 1971 photographs following one of those floods. These scenes looking both ways on Marshall Street show Markley Street torn up by the flooding with Simpson Brothers Mill on the right and the and the Adam Scheidt Brewing Company on the left in the background. (Bill Landis.)

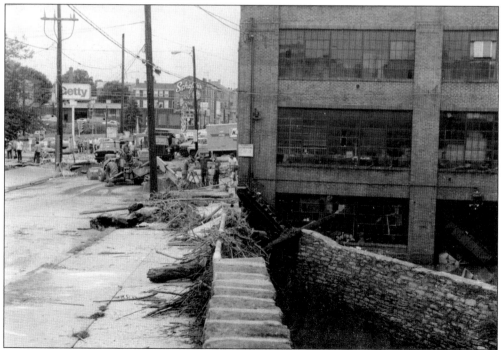

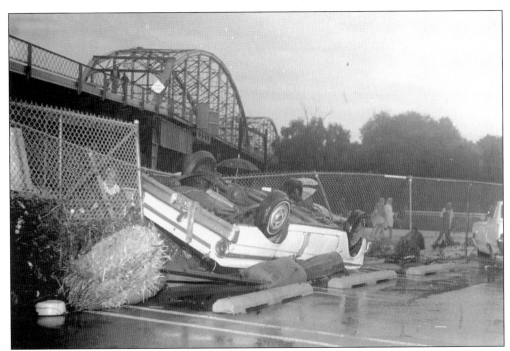

Floods have devastated the borough of Norristown over the years like this 1971 flash flood. Massive flooding in the area of Markley and Marshall Streets from the Stoney Creek have cost business owners and home owners millions of dollars over the years. In the 1960s, the Pennsylvania Department of Forests and Waters built a flood control dam on Sawmill Creek to help prevent flooding from causing this kind of damage to Norristown along the Stoney Creek. The flooding was severe enough to flip cars and trucks completely over. (Bill Landis.)

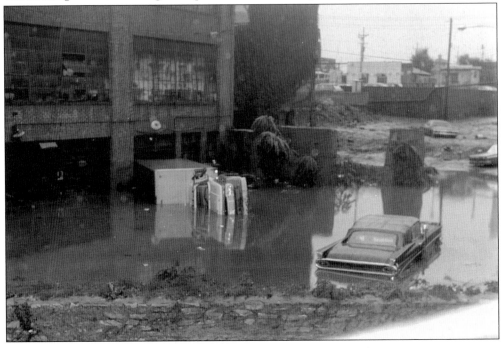

Five

CELEBRATIONS

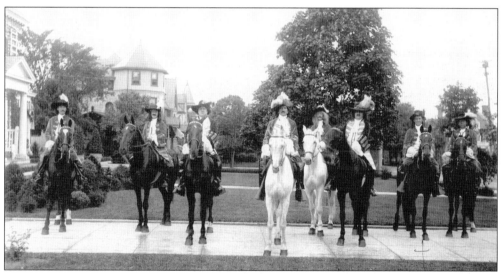

A number of grand marshals and assistant grand marshals pose during the borough's 1912 centennial celebration. The celebration started on May 5, 1912, and what followed for an entire week was nothing less than spectacular. Norristown's three newspapers claimed "A Brilliant Affair" and "the Pageant was Superb," and the *Norristown Times* stated "A two mile pageant, gorgeous in costuming, rich in historical lore, of great educational value, and interesting in its personnel and characteristics, marked Historical Day." Posing on their parade horses from left to right are William Benner, Russel Neiman, Frank Boyer, Samuel Roberts, William Yost, O. F. Lenhardt, Ben Evans, and Frank Stritzinger. The photograph was taken on Dekalb Street in front of H. B. Tyson's house. The homes in the background were later demolished to make way for Sacred Heart Hospital. (Historical Society of Montgomery County.)

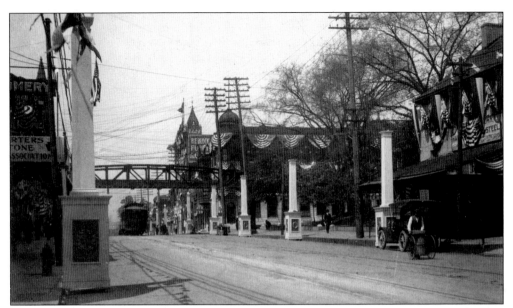

A view of East Main Street looking west in 1912 shows Norristown decorated in honor of the town's centennial. The borough was granted a charter on Tuesday March 31, 1812, when signed into law by Pennsylvania governor Simon Snyder. Notice the automobile on the right and the P&W trolley bridge crossing over Main Street, having been completed just months earlier. Further down West Main Street, in the center of the photograph, notice the trolley under the bridge and Blocks Furniture and Department Store. (Historical Society of Montgomery County.)

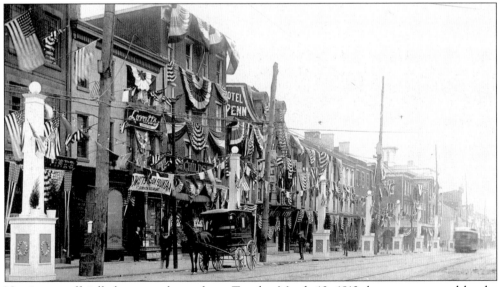

Norristown officially became a borough on Tuesday March 12, 1812, by an act granted by the legislature of the State of Pennsylvania, and signed by Governor Snyder. Previously Norristown was an unincorporated village and a part of Norriton Township. One hundred years after incorporation, the borough celebrated with a weeklong schedule of events that the borough has not seen since. In 1812, Main Street was decorated and many events and parades took place. This Main Street scene in May 1912 shows Lomatts Drug store, with a banner that reads Lomatts Soda Fountain, "It serves you right." (Historical Society of Montgomery County.)

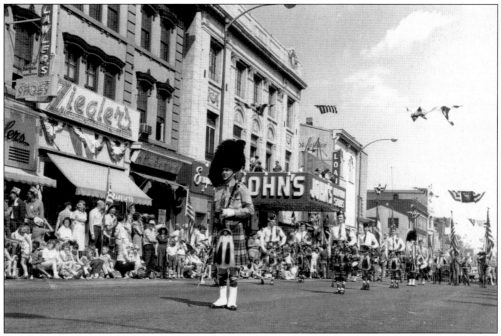

It was a great day for a parade on May 12, 1962, as thousands of residents lined the borough's Main Street to witness the parade that lasted for hours. (Historical Society of Montgomery County.)

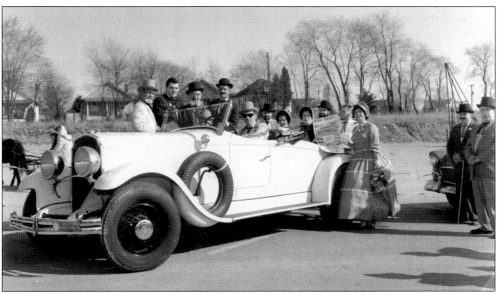

A number of sesquicentennial caravans were held throughout the spring of 1962 to spread the word of Norristown's celebration. A group of residents, dressed in early-20th-century clothing, would travel in old cars and trucks to meet and greet residents from other areas, including Hatfield, Lansdale, North Wales, and Souderton. A group of appropriately attired celebrators in this photograph includes Holly Santillo, Richard Moser, Roland Collins, Leon Nester, Herbert Morey, Arthur Freas, Mrs. Charles Knauer, Mrs. Vincent McGough, Mrs. Harry Atkinson, Fiore B. Trecoce, Russell Trecoce, and Ron Horning. (Bill Landis.)

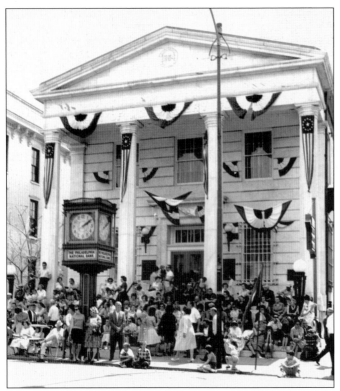

Thousands upon thousands of residents and visitors participated or viewed the borough's sesquicentennial weeklong celebration in 1962. While all the residents enjoyed the festivities, very few realized the hundreds of residents involved in making the celebration a success. In this photograph, taken on a sunny day in May 1962, residents gather for one of the parades in front of the old Philadelphia National Bank on Main Street. (Historical Society of Montgomery County.)

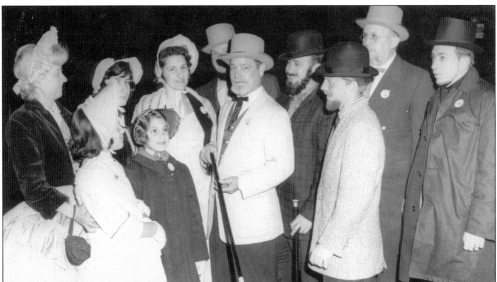

In the spring of 1962, Norristown celebrated 150 years of incorporation. In April 1962, a group of promenaders, dressed in early-20th-century clothing, gathered to help kick off the sesquicentennial celebration. In the center of the photograph with the top hat and cane is Holly Santillo, chairman of the Promenade Night Committee. Also shown from left to right are Mary Howard, Rose Marie DiSante, Mrs. Sullivan Asko, Allesandra Asko, Linda Lombardi, Pasquale Frangiosa, Santello, Vigel Lepore, Jacob Bregler, Barry Miller, and Pete Podolnick. (Historical Society of Montgomery County.)

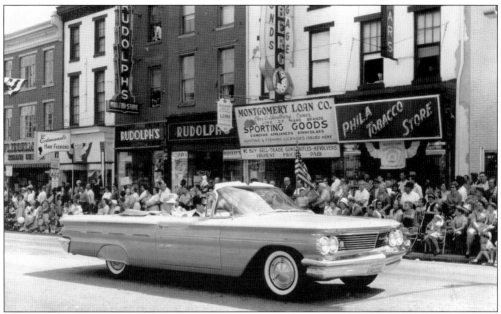

When Norristown celebrated its sesquicentennial in 1962, Main Street was still a thriving retail district—the borough had 550 retail outlets that included 70 barbershops, 32 gas stations, 53 groceries and meat retail shops, 20 shoe repair shops, and 90 luncheonettes and pizzeria restaurants. When the sesquicentennial parade hit Main Street, thousands of residents and visitors were camped out on the sidewalks; in some places the crowd was 10 people deep on the sidewalk to view the parade. In the years to come parking became a problem for Main Street America; then the enclosed shopping malls popped up in King of Prussia and Plymouth Meeting, shoppers had parking and were sheltered from the weather and found all their needs under one roof. (Historical Society of Montgomery County.)

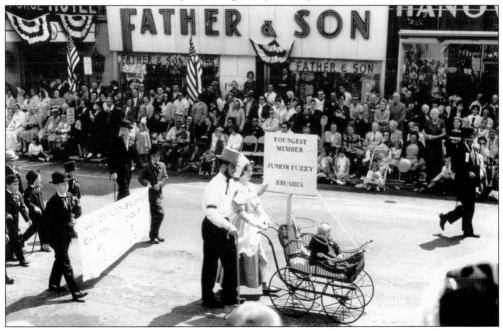

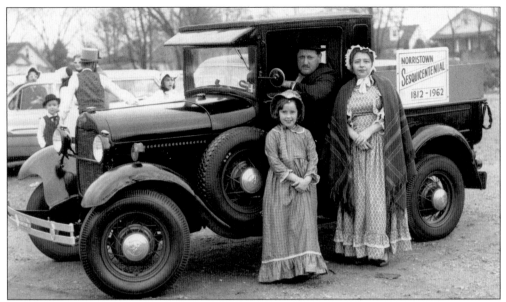

Dressed in period clothing to replicate how a family may have dressed in 1812, members of the Wambold family dressed in celebration for the Norristown sesquicentennial held. From May 4 through May 12, 1962, Norristown celebrated its incorporation with dozens of events including mini parades or caravans. Mr. and Mrs. Robert Wambold pose with their daughter Barbara for this *Times Herald* photograph just before the caravan pulled out. (Historical Society of Montgomery County.)

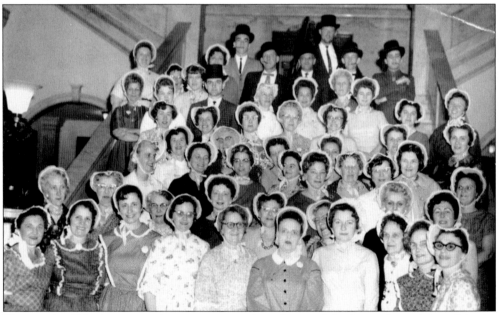

Thousands of Norristown residents, visitors, and employees of the borough participated in the borough's sesquicentennial celebration event in 1962. Dozens of events throughout the borough commemorating the birthday of the borough were held, including Dress-up Day held on Friday, March 30, 1962. County courthouse employees certainly enjoyed wearing bonnets and top hats, not to mention the many surprised visitors to the courthouse that day. (Bill Landis.)

76

Residents of Norristown packed the sidewalks on a beautiful day in May 1962 to enjoy a parade celebrating the borough's sesquicentennial. The town of Norris was a growing village in 1800, and by 1811, the town's population had grown to nearly 400 residents. A charter was submitted to the state of Pennsylvania, and on March 31, 1812, Norristown was officially incorporated. The borough celebrated its sesquicentennial with a week full of activities, including Loyalty Day, Faith of our Fathers Day, Youth Day, and Ladies Day, not to mention the Sesquicentennial Day parade. (Historical Society of Montgomery County.)

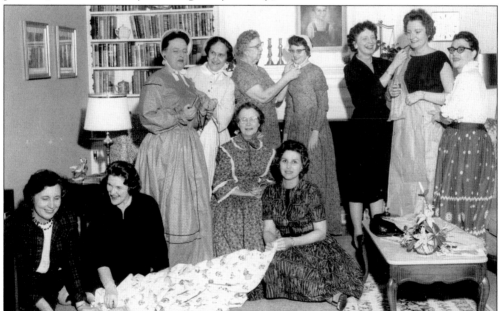

The Celebration Belles gathered in March 1962 for a sewing session to make their costumes for the upcoming sesquicentennial celebration. From left to right are (first row) Dertude DeChant, Mrs. Lester Teepell, Mrs. Mayme Rothenberger, and Mrs. Robert Hower; (second row) Dorothy Landes, Mrs. Victor Glenn, Alma Swartley, Connie Northup, Mary Kopenhaver, Jean Faltinow, and Mrs. Harry Righter. (Historical Society of Montgomery County.)

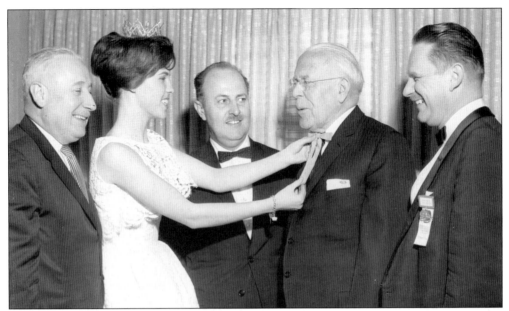

The 1962 Norristown sesquicentennial celebration brought Pennsylvania governor David Lawrence to town. He is seen here being presented with a 150th anniversary tie by Sesquicentennial Queen Susan Shannon. Governor Lawrence attended a dinner at Cross Roads Motel located on Dekalb Pike. Also attending the event were Robert McCracken (left), president of the Sesquicentennial Committee; state representative Walter C. Fry (center); and Alfred Taxis Jr. (right), chairman of the Anniversary Committee. (Bill Landis.)

Thousands of residents packed Main Street in May 1962 to watch the Sesquicentennial Day final parade with celebration themes and costumes. (Historical Society of Montgomery County.)

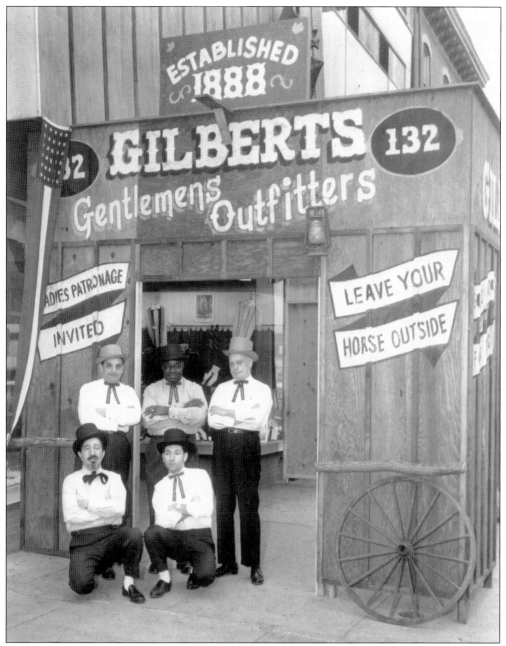

Gilberts Clothing for Men, established in 1880, was located at 132 West Main Street directly across from the Norris Theatre. In 1962, Gilberts celebrated 75 years of service as the borough of Norristown celebrated its sesquicentennial. Gilberts rebuilt its storefront in honor of the celebration, taking residents back in time. Posing in front of the makeshift storefront and appropriately attired are, from left to right, (first row) proprietor Morton Weiss and Francis Chiarovolloto; (second row) Anthony Storti, William Thompson, and Stephen Green, all members of the Gilberts sales staff. (Historical Society of Montgomery County.)

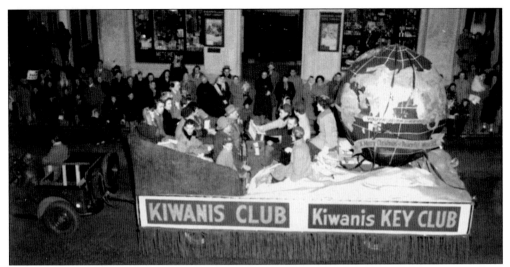

The Kiwanis Club float, with a theme of a peaceful world, was a big hit during the 1962 West Marshall Street Christmas parade. Dozens of floats participated, and thousands of residents watched and participated at the annual event. This photograph was taken in front of the West End Bank on the 500 block of West Marshall Street. The Kiwanis Club of Norristown was chartered on May 27, 1924, and for many years raised money for underprivileged children. In 1962, when this photograph was taken, Marlin B. Brandt was the president of the organization and Frederick Lobb and William Corey were both vice presidents. (Tony Cottonaro.)

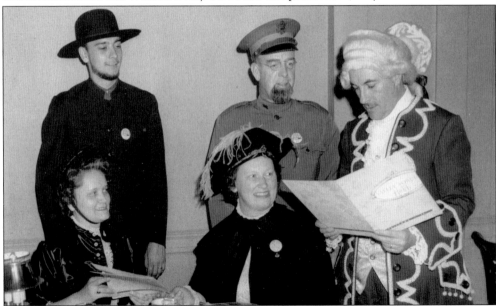

When Norristown was incorporated in March 1812, the town was still nothing more than a village with only 400 residents; 150 years later, the borough's population had swelled to nearly 40,000 residents. In honor of the borough's sesquicentennial, a large banquet was held at the Valley Forge Hotel and included Mrs. Carl Espenship and Mrs. Harry Houpt seated with their husbands, Carl and Harry. Andrew Malone, the manager of the hotel, was dressed in Colonial costume and was discussing the dinner choices with the invited guests. (Historical Society of Montgomery County.)

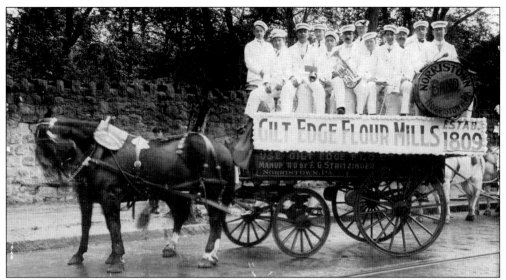

This 1890 photograph of the Norristown Band was taken just before a parade began on Main Street. The band members in the horse-drawn wagon are showing off their instruments and are sponsored by the Gilt Edge Flour Mills Company. Norristown was a thriving community in 1890 with 18 hotels and nearly 20 churches and 15 blacksmiths. In 1890, horses were the main means of transportation as the Schuylkill Valley Transit Company was not developed until 1893. (Marjorie Rigg.)

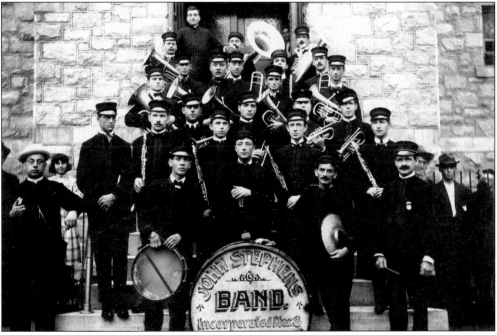

Members of the John Stephens Band pose for this photograph in front of the Holy Savior Church on July 16, 1909. The Norristown Band was formed in 1902 and was sponsored by the Stephens Music Store, once located on Main Street between Barbadoes and Markley Streets. In the early 20th century, it was common for almost every town to have a number of bands representing stores, churches, clubs, or organizations.

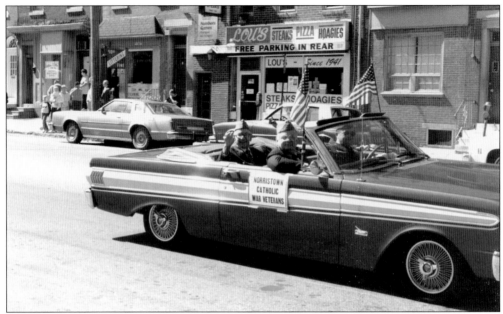

One of Norristown's many parades over the years shows the Norristown Catholic War Veterans car with Charlie Modanno in the back seat. Modanno was the founder of Norristown Excavating and passed away at 103 years of age. Notice the ever popular Lou's Steakhouse, a Norristown staple since 1941, in the background.(Charlie Madonna.)

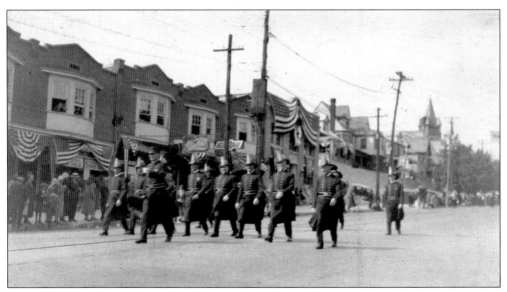

Members of the Montgomery Fire Company march in a 1924 parade along Fayette Street in Conshohocken. Thousands of residents lined the main street in honor of the Washington Fire Company of Conshohocken, celebrating 50 years of service to the community. The Montgomery Fire Company of Norristown was formed in 1847, two and a half years before the borough of Conshohocken incorporated as a borough and more than 25 years before the Washington Fire Company was chartered.

Six

PEOPLE

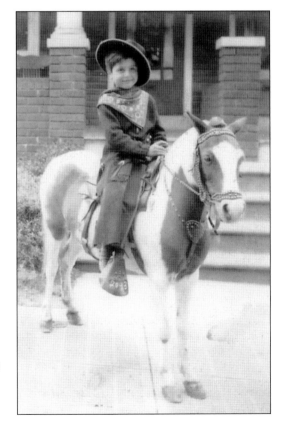

This 1935 photograph of Tony Bono posing on a horse was taken by a traveling photographer who charged 25¢ for the picture, which included the use of the cowboy outfit. Bono was in second grade at the time, attending the former George Washington School, then located on the 600 block of East Marshall Street. The George Washington School was built and completed in 1922 and closed as a school 47 years later in 1969. The photograph was taken in front of the young Bono's house, located at 738 East Marshall Street, where he lived for 20 years. (Michael Bono.)

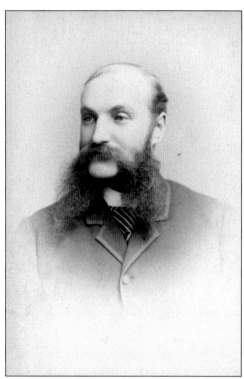

Daniel Miller Yost was the founder of the D. M. Yost Company, once located on the corner of Main and Dekalb Streets. Yost was born in Pottsgrove Township in 1839, one of 10 children born to Isaac and Rosina Miller. At age 15, Daniel became a store clerk at Rambo and Major, located at 104 East Main Street. Yost worked as a clerk until the beginning of the Civil War. He was disabled in the early stages of the war and returned home. In March 1862, Yost, along with I. H. Brendlinger, bought Spencer Thompson's store, located on the corner of Main and Dekalb Streets, and added a second story to the building. On April 12, 1862, the D. M. Yost Company was open for business. Yost passed away in 1912, but his business continued to flourish for more than a century. (The Yost family.)

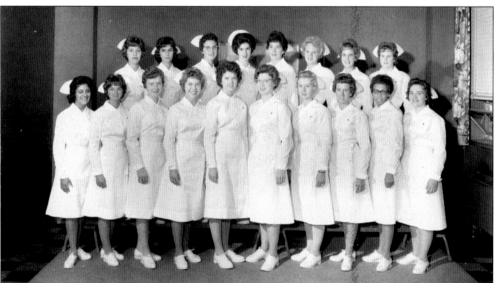

Montgomery Hospital was founded in 1889 by a group of citizens who chartered the hospital after raising enough funds to purchase a site on the corner of Powell and Basin Streets. The hospital officially opened on January 1, 1891, as the Charity Hospital of Montgomery County. It was officially renamed Montgomery Hospital in 1920. On April 1, 1893, Margaret Mowbray was named chief nurse and superintendent of the hospital's nurses training school. The nurses above pose for their 1963 graduating photograph from the nursing school. After graduating more than 1,100 nurses over 73 years, the school closed its doors in November 1975. (Historical Society of Montgomery County.)

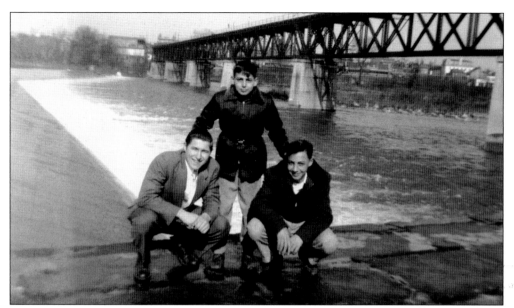

Three well-dressed residents pose for a photograph in front of the Norristown Dam, on Easter Sunday in the mid-1950s. Posing from left to right are Rocky Pignoli, John Mattiola, and John's little brother standing in the back. The bridge on the right is the P&W trolley line that runs from Sixty-ninth Street in Philadelphia's Upper Darby section of the city to Norristown. The P&W bridge was constructed in 1911 and combined with the Schuylkill Valley Transit Trolley established in 1893. (Rocky Pignoli.)

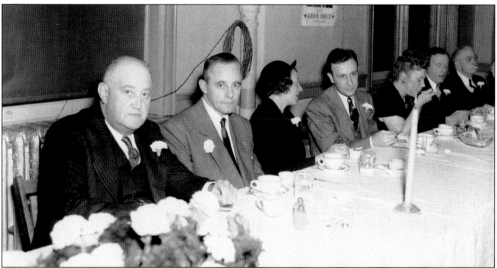

Democratic county chairman Raymond K. Mensch (left) sits next to the future mayor of Philadelphia, attorney Richardson Dilworth, on October 19, 1948, at Norristown City Hall. J. Alfred Marquette, Frank A. Keegan, Raymond Currigan, and Emily Khle also shared the head table with Dilworth. Dilworth, who was defeated in the 1947 Philadelphia mayoral election, was the keynote speaker at the Democratic rally for the impending presidential election. Mayor Dilworth was vacationing with his wife on the *Andrea Doria* on July 25, 1956; the ship collided with another liner at sea, 60 miles off Nantucket Island. A total of 52 passengers lost their lives, but Dilworth and his wife survived along with 1,600 other passengers and crew members. (Tony Cottonaro.)

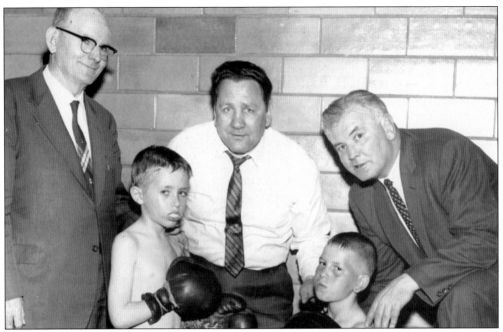

David Burdge and Joe Pennington, two members of the Norristown Police Boys Club boxing program, pose for a picture at the Stewart Armory in May 1957 following a Kid Mittens boxing show. Also pictured are Gus Lesnevich (center), a former light heavyweight boxing champion, and Jim Braddock (right), known as "the Cinderella Man." Braddock, a former world heavyweight champion, fought 86 fights, winning the championship on June 13, 1935, against Max Baer. In 2005, Braddock was depicted in the movie *Cinderella Man*, and was played by Russell Crowe. Standing on the left is Norristown police chief Robert Reilly. (Hank Cisco.)

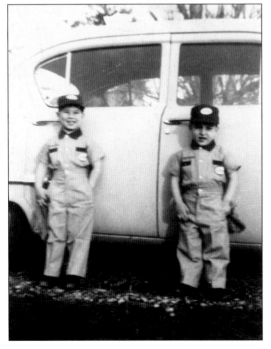

In 1956, Carmen Frangiosa (left) and Frank Bingham dressed in their official Esso Service Station attendants' uniforms. The photograph was taken at 1020 East Main Street where the Frangiosa brothers owned and operated an Esso Station for 35 years. (Lou Frangiosa.)

Michelle and Michael Bono pose with Pennsylvania governor Edward Rendell at the 11th annual Norristown Days held on Main Street in 2004. Norristown Days was founded in 1993 and is celebrated on the first Saturday in June. It is a day that encourages Norristown families to participate in the celebration, which includes a car show, history booths, food, and vendors. Each year more than 2,000 residents participate along with local celebrities and borough council members and other officials. (Michael Bono.)

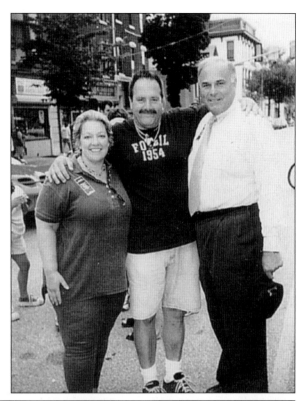

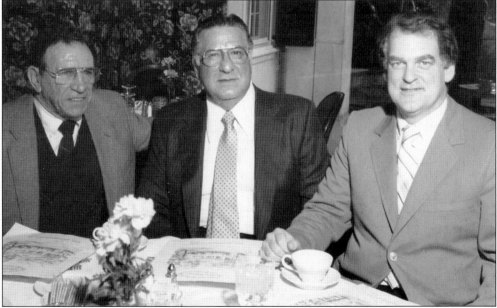

Retired police officer Hank Cisco, on the left, enjoys a dinner at the Jefferson House with former Philadelphia police commissioner and former mayor of Philadelphia Frank Rizzo in the center and Judge Joseph Smyth on the right. In the mid-1970s, Norristown employed 65 police officers. Cisco was a police officer for 24 years, retiring in 1976 to become a Montgomery County detective. (Hank Cisco.)

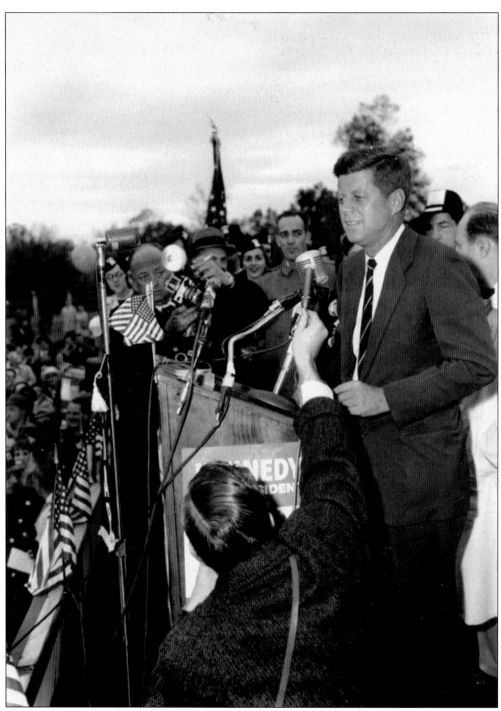

Massachusetts senator John F. Kennedy was in Norristown on October 29, 1960, to address more than 10,000 local residents at Roosevelt Field. Kennedy was in a close presidential race with then vice president Richard M. Nixon. Nixon made an appearance in Norristown a week earlier to address a crowd at the Montgomery County Courthouse. Kennedy is seen in this photograph standing at the podium addressing the residents. (Bill Landis.)

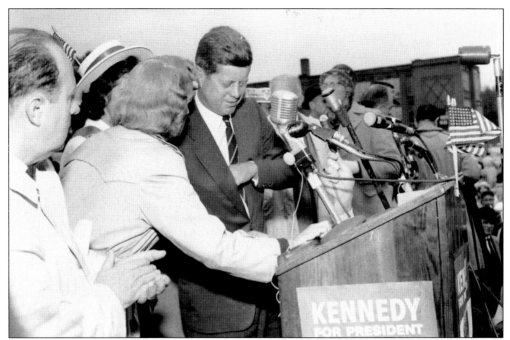

On Saturday, October 29, 1960, Massachusetts senator John F. Kennedy made six stops in Montgomery County including Roosevelt Field and Valley Forge Country Club in Audubon. More than 10,000 area residents turned out on a rainy day at Roosevelt Field to witness the presidential candidate enter Roosevelt Field riding in a convertible. Kennedy stepped out of the car to greet and shake hands with thousands of supporters. A week later on November 8, 1960, Kennedy was elected president of the United states despite losing in Montgomery County by nearly 50,000 votes. (Bill Landis.)

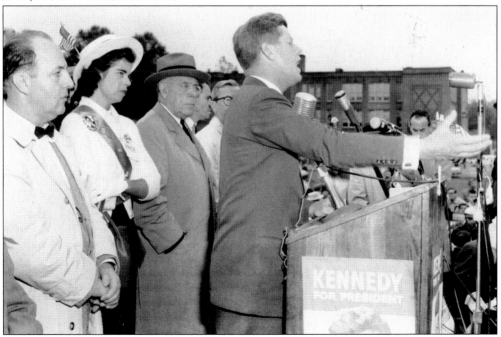

It was just an old-fashioned snowball fight between two brothers, Gus (left) and Tony Bono. In the winter of 1944 America was at war and President Roosevelt approved a $100 billion military budget. In Norristown the average cost of a new home on East Marshall Street was $3,600, and the average cost of a new car was $900. The Bono family lived at 738 East Marshall Street. (Michael Bono.)

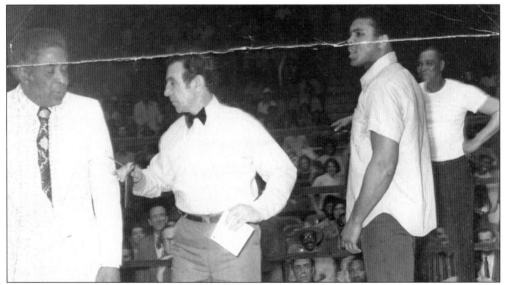

Frank Ciaccio, better known as Hank Cisco, shown in the center of the photograph, is a Norristown legend. A former police officer and former professional boxer, Cisco later became a professional referee. Cisco is shown getting in between Yank Durhame, who at the time was Joe Frazier's manager, and Muhammad Ali. Ali was the heavy weight champion of the world three times during his career, beating the best along the way like Sonny Liston, Floyd Patterson, Ernie Terrell, Ken Norton, Joe Frazier, and George Foreman. Ali won 57 professional fights during his 21-year career, 37 by knockouts. (Hank Cisco.)

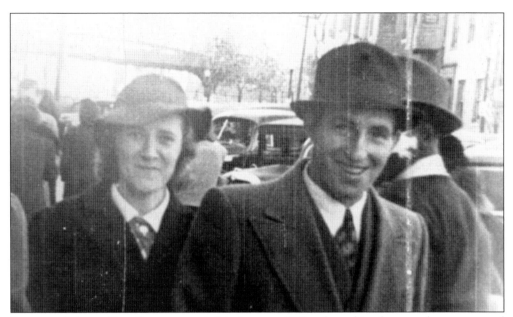

Ernest and Anna Pignoli were married in January 1933, when this photograph was snapped outside the Valley Forge Hotel located on East Main Street and Strawberry Alley. The old P&W trolley bridge can be seen in the background running up Swede Street. The Pignolis lived on Summit Street in Swedeland for many years and had four children. Ernest worked at the Gulph Mills Golf Course for most of his life, starting in 1921. (Rocky Pignoli.)

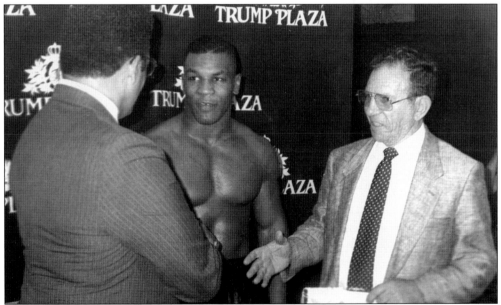

Professional boxer Mike Tyson (center) fought one of his 58 professional fights at the Trump Plaza Casino in Atlantic City, and Norristown was present to make a presentation to Tyson. On the left was Norristown police chief Oscar Vance, and to the right making a presentation to Tyson was retired police officer and professional referee Hank Cisco. Cisco, himself a former professional boxer, said he admired "Iron Mike" Tyson for his record, having won 50 fights in his career. (Hank Cisco.)

The Fourth of July Committee celebrates in 1921 on the 900 block of West Lafayette Street. Pictured from the left to right are (first row) Thomas Carter, Eugene Ault, and Harry Karnes; (second row) Mr. Reiff, Amos Famous, Mr. Loux, Emanuel Bortman, and John Duddy. The Fourth of July was celebrated at Elmwood Park in 1921, and more than 10,000 residents showed up for the full day of activities that started with raising the flag and finished with an hour-long fireworks display over the park. (Historical Society of Montgomery County.)

The sport of football has been played in Norristown as early as 1890 and organized football as early as 1893. This Norristown 11 lines up in the old stockade long before it became Roosevelt Field. Over the years Norristown has produced dozens of professional athletes and many others who went on to play semiprofessional ball, such as this bunch from 1929.

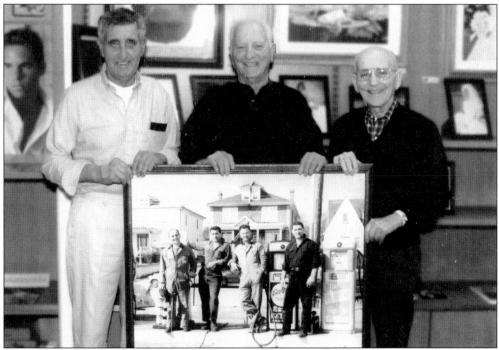

The Frangiosa brothers are enjoying retirement but love looking back at their more than 35 years in the gas station business. The brothers owned a gas station on East Main Street for 35 years starting in 1951. When they started, cars did not have air-conditioning, and they did not accept credit cards. The four brothers in the picture they are holding from 1957 are Lou, Tony, Joe, and Carmen. Holding the photograph from left to right are Lou, Tony, and Joe. Carmen passed away before this photograph was taken, and Joe has since passed away. (Lou Frangiosa.)

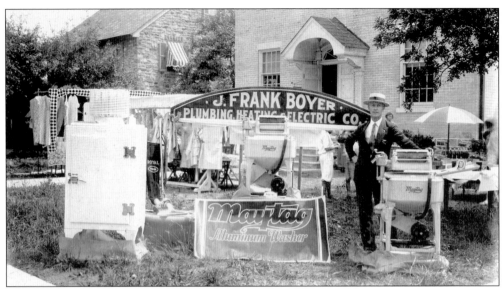

J. Frank Boyer was president of the company with his name on it selling plumbing, heating, and electric supplies from his store once located at 51 East Main Street in the Arcade. The Arcade was a mini mall that ran from Main Street to Penn Street housing more than a dozen offices. Boyer was displaying the Maytag brand of appliances to residents of the Franklin Residence Apartments in 1929, looking for sales on the latest Maytag washers and refrigerators.

On March 19, 1936, Amelia Earhart, "the First Lady of Flight," visited Norristown and was the guest speaker for the Norristown Business and Professional Women's Club. Earhart spoke to a standing-room-only crowd at the Norris Theatre, located on West Main Street. Earhart is seen getting in her car with an unidentified man standing alongside the car. The photograph was taken outside the Valley Forge Hotel, then located at 20 East Main Street. In July 1937, Earhart and her navigator Fred Noonan were on the last leg of a record-setting 29,000-mile flight in an attempt to fly around the world at the equator. Earhart's plane was low on gas, and she had been flying for more than 24 hours. After a number of radio transmissions to a waiting ship, she and Noonan were never heard from again. (Jack Coll Library.)

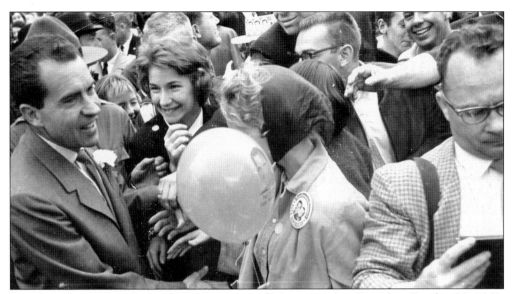

Presidential candidate Richard M. Nixon visited Norristown on Saturday, October 22, 1960. Nixon spoke in the public square to an enthusiastic crowd estimated at more than 20,000 local residents. Nixon is seen here shaking hands with residents at the corner of Main and Swede Streets. *Norristown Times Herald* photographer Bill Landis snapped many photographs of Nixon during his visit, but not this one. Landis, who captured the history of Norristown for nearly 40 years through the lens of his camera, can be seen to the right of this picture loading film in his camera. (Bill Landis.)

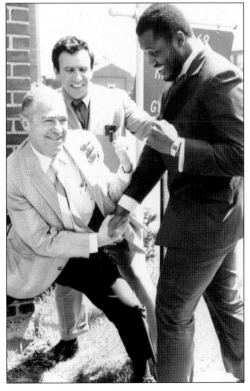

Former Norristown police sergeant Frank Ciaccio and former Philadelphia 76ers basketball legendary announcer Dave Zinkoff would visit the Valley Forge General Hospital on a regular basis to entertain wounded Vietnam veterans. Cisco would often bring celebrities to sign autographs and talk to the veterans. On one of those occasions, former heavyweight champion of the world Joe Frazier attended with Zinkoff (left) and Cisco (center). (Hank Cisco.)

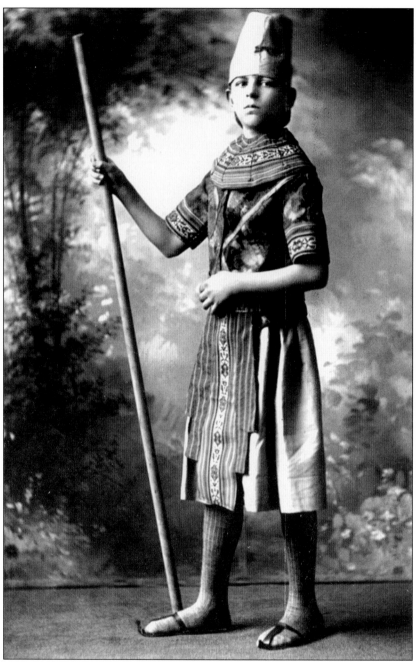

"Into the Tomb" was the line that Dan Yost had in the school play in the early 1920s when he attended Rittenhouse school. The school was named after David Rittenhouse, who was a world-famous astronomer, a surveyor, a professor at the University of Pennsylvania, the first state treasurer in Pennsylvania, and an appointee of Pres. George Washington as the first director of the United States Mint in Philadelphia. Yost's family owned the D. M. Yost Company located at Main and Dekalb Streets, and Dekalb and Airy Streets. One of the items the Yost store specialized in was the making of window awnings, and Yost's costume was made at the store out of the awning material, which worked perfectly for the school play. (The Yost family.)

Seven

SPORTS

Football was introduced to Norristown on Thanksgiving Day in 1892, when Norristown High School played a squad from the Norristown YMCA. The game was well received, and word spread throughout the Norristown area of the big game. Some of the early games were played with the Norristown High School boys competing against older teams. By 1893, Norristown fielded an independent team that played professionals from Conshohocken, losing a game early in the season, but on Thanksgiving Day in 1893, Norristown took its revenge, beating the Irontown boys 40-0. By 1894, a number of teams represented Norristown, including members of the Catholic Athletic Association Football Club. (The Yost family.)

Norristown has a long, rich sports history that dates back to the 1880s with football, basketball, baseball, and a handful of other sporting events of the day. During the 1920s and 1930s, club leagues or neighborhood leagues became popular and one of those league's involved bowling. In 1931, members of the *Norristown Times Herald* newspaper were crowned city champions as they posed at the front door of the Norristown newspaper.

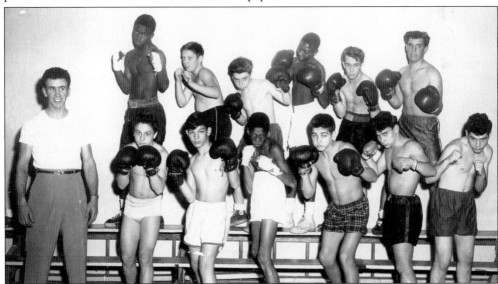

One of the first professional boxing matches held at the Police Athletic Club in the borough featured George Dixon and Charles McKeever in 1892. In the 1950s, boxing in Norristown was at an all-time high with dozens of youngsters participating in boxing programs. This group of boxers fought at the Norristown YMCA. From left to right are (first row) Hank Cisco, Tommy Cane, Gus Monteleone, Bobby Manning, Kenny Tarlecki, Tony Pelatti, and George Uriani; (second row) Eddie Butler, Mike Kreno, Eric Hubbard, Buck Rinehart, Frank Supplee, and Freddie Catagnus. (Hank Cisco.)

Proud members of the YMCA gymnastics team and swimming team are seen in these photographs taken on February 15, 1965. Norristown's YMCA played a role in many of the borough's young residents going on to be successful adults. Attempts were made to organize a YMCA in the borough as early as 1857, but it was not until 1885 that a headquarters was established in the rooms of the Young Men's Temperance Union. In 1890, the organization purchased a building at 406 Dekalb Street, and by 1923, the organization constructed a building on Airy Street on the former site of the old Veranda House Hotel. The YMCA occupied the building until the early 1980s. (Historical Society of Montgomery County.)

The Norristown High School has fielded many prominent sports teams over the years, including the 1934 girls' tennis team. In 1934, Emma E. Christian was principal at Norristown High School and Caroline Rhoads was the vice president of the class. From left to right are (first row) M. Burkert, M. Howe, B. Lippincott, J. Howe, and S. Lattimore; (second row) F. Panico, K. McCool, M. Paxon, V. Geyer, K. Schiele, J. O'Neil, D. Wagenhurst, M. Opperman, and E. McAdoo. In 1934, Norristown had 13 public schools, with a total of 6,214 students.

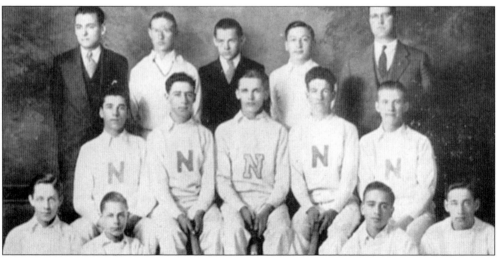

In 1934, Norristown high school students had a very promising outlook beyond high school. The borough was home to more than 100 diversified manufacturing establishments offering more than 9,000 jobs at every level of these companies. A number of the members of the tennis team in 1934 went to work for some of the Norristown manufacturers. Members of the team included, from left to right, (first row) W. Canning, W. Marberger, W. Noble, and T. Skinner; (second row) H. Skeen, W. Kneas, D. Barrett, D. Rowland, and W. Wolfe; (third row) R. Gerhard, R. Royer, H. Gardner, L. Gerson, and coach Babb.

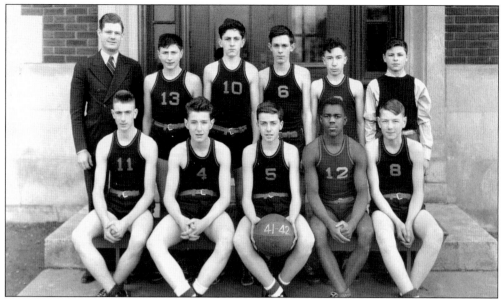

Members of the 1941–1942 Stewart Junior High School Basketball Team poses for a photograph in the early spring of 1942. Not many basketball players were thinking about college in the early 1940s, as a war was on and many of our country's young athletes enlisted in the war effort. From left to right are (first row) Peirce Davis, Jas Brown, Oliver Smith, James Weaver, and Bob White; (second row) coach Kermit Gulden, Bob Novell, Gus Gazona, Bill Forsyth, Howard Fehl, and manager Stanley Knipe. (Historical Society of Montgomery County.)

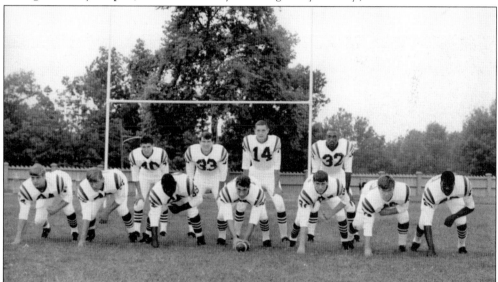

Competitive football came to the borough of Norristown in the early 1890s. The *Norristown Times* started reporting on games between Norristown and Conshohocken as early as 1893. Over the years, Norristown's football teams and their fans were both known as tough and always competitive. When football started in the borough, the teams were mainly sponsored by clubs like the Young Men's Athletic Association (YMAA) or the Lodge Antioni Muchi (LAM) Club. In the photograph above, the 1965 Norristown High School boys' varsity football team lines up for a team picture. (Historical Society of Montgomery County.)

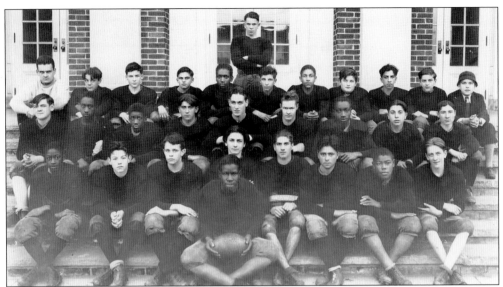

The Norristown Rittenhouse Junior High School football team of the early 1950s poses for a team photograph outside the school. Sports has become a major focus of Norristown High School over the past half century as many of Norristown's students have successfully gone on to college and professional sports. Notable in the photograph is Daniel M. Yost, third row second from right. Daniel is the grandson of Daniel Miller Yost, who founded the D. M. Yost Company with a retail outlet located on the corner of Main and Dekalb Streets for more than a century. (The Yost family.)

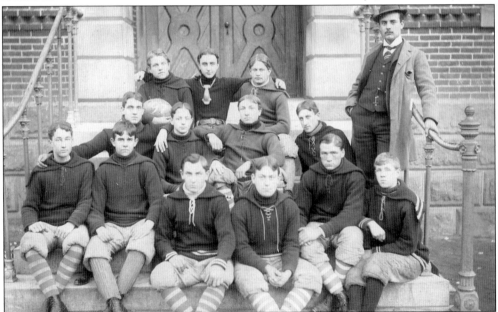

Norristown public schools came into existence by vote of the citizens in 1835; by the late 1880s, sports became part of the Norristown community; and in 1892, Norristown High School fielded their first football team. This 1897 photograph of the football team shows the players in padded uniforms including high-top sports shoes. Members of the team included, in no particular order, Frank Myers, captain Roland Whitz, Will Lovett, Rohn Dettera, Walt Smith, Erobert Stockdale, James Kite, ? Yosh, ? Haldeman, ? Supplee, ? Wetzel, and the team manager Dan Bearer. (The Yost family.)

Eight

A FEW BUILDINGS

A young Morris Cohen poses in front of Myers pharmacy located at 330 Dekalb Street in 1930. He later moved the business to 328 Dekalb Street, where Myers Drug Store is still operating today. The drugstore has served the residents of Norristown continually since the mid-1860s. (Myers Drug Store.)

The Grand Theatre was located at 67 East Main Street and was one of four theaters located in the borough in 1939 when this photograph was taken. The Norris Amusement Company, owned and operated by the Sablosky brothers, operated all four theaters in the borough including the Grand, Norris, Garrick, and WestMar. In 1939, when Johnny Weissmuller and Maureen O'Sullivan starred in *Tarzan Finds a Son*, Americans were enjoying the post-Depression era when going to the movies cost 25¢ for a double feature. (Bill Landis.)

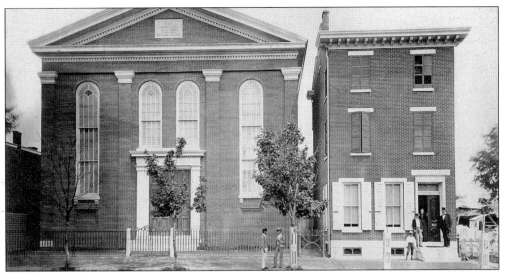

This 1860 photograph shows life on Dekalb Street in front of the newly built Methodist church. The Methodists organized in Norristown in 1832, and built their first church on East Main Street below Arch Street, but quickly grew out of the building. In 1858, the congregation moved into this beautiful structure on Dekalb Street just below Marshall Street. By 1875, two groups of Methodists merged and formed United Methodist Church of Haws Avenue.

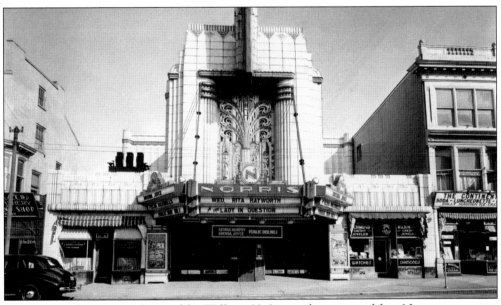

The Norris Theatre was designed by William H. Lee and was one of four Norristown movie theaters owned and operated by the Sablosky brothers. The Norris opened on December 22, 1930, and was the pearl of theaters in Norristown. This 1940 photograph shows the marquee with *The Lady in Question* starring Glenn Ford and Rita Hayworth. Sid Richmond Jewelers was next door, and the Continental Luncheonette is shown to the right. Popular movies in 1940 also included *Rebecca*, Academy Award winner for 1940; *Our Town*; *The Long Voyage Home*; and *The Grapes of Wrath*. John Steinbeck also won a Pulitzer for his book *The Grapes of Wrath*. (Bill Landis.)

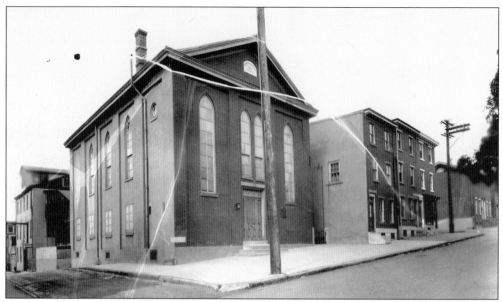

New Hope Baptist Church currently occupies this building located at 206 East Oak Street, just below Green Street. St. Paul's German Lutheran Church organized in 1872 and built this church in 1873. In 1873, Norristown had a population of more than 11,000 residents with 18 churches. St. Paul's German Lutheran congregation moved to East Norriton in 1948. New Hope Baptist Church was founded in 1919 and incorporated in 1925. Members of the First Baptist Church first began meeting in Norristown in 1832, they held services at the courthouse.

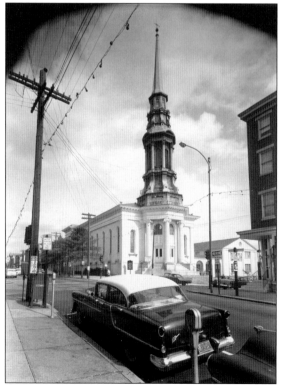

This mid-1950s photograph was taken at the corner of Dekalb and Airy Streets showing the First Presbyterian Church. Note that Airy Street was a two-way street. The direction sign on the right of the photograph directs the motorist if they go straight Doylestown is 19 miles; if the motorist takes a right-hand turn, Philadelphia is 20 miles; and should the motorist take a left, Pottstown is 20 miles.

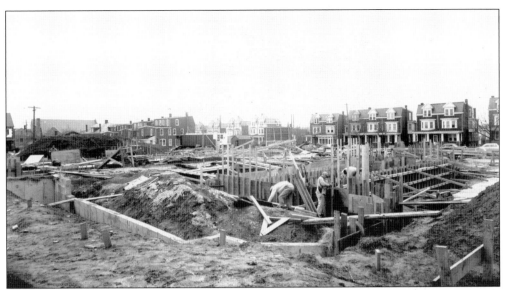

St. Francis of Assisi Church was founded in 1923 in Norristown at a time when the borough housed 28 churches. St. Francis of Assisi was the borough's second Catholic church; St. Patrick's Roman Catholic Church was founded in 1835, and was Montgomery County's first Catholic church. It is not known when the first Catholics arrived in the area, but Catholic immigrants belonged to the congregation founded in 1741 at Goshenhoppen, located in Berks County just outside Montgomery County. Both photographs were taken during construction of the current St. Francis Church located on the 1100 block of West Marshall Street between Hamilton and Buttonwood Streets. The top photograph shows early construction in March 1954, while the lower photograph shows construction in November 1954. (Historical Society of Montgomery County.)

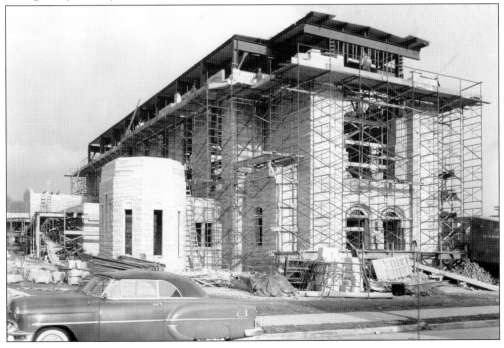

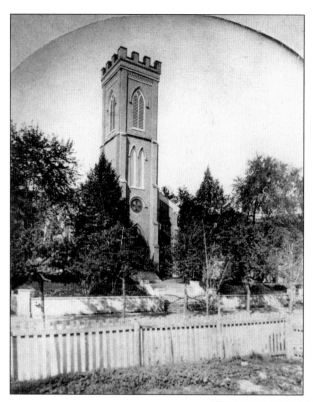

St. John's Episcopal Church, located on the north side of Airy Street between Swede and Dekalb Streets, is the borough's oldest church. St. John's was established in 1812, the same year the borough incorporated. The church was built in 1815 and rebuilt in 1856. This photograph shows a residence fence from the opposite side of Airy Street, perhaps where the courthouse or post office is now located.

In 1832, a small group of Methodists that included eight members organized in Norristown, and within a couple of years the group had grown to more than 100 members and a church was built on East Main Street below Arch Street to hold Sunday services. Nearly 25 years later in 1858, the congregation built this new church at 542 Dekalb Street. Over the years, the Methodists have merged several times within the borough and the church building was sold. The building was used for a number of years as the Norristown Library and later the Jefferson Trade school for a while and is currently the Faith Tabernacle House of Prayer, Inc. (Bill Landis.)

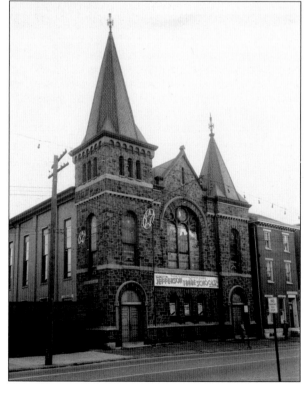

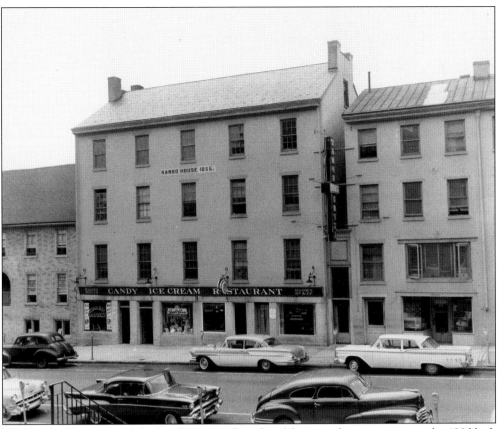

The Rambo House, established in 1855, served as a hotel for more than a century on the 400 block of Swede Street. The top photograph was taken in the late 1950s; and the photograph below shows the hotel in the mid-1920s. The hotel had a nice restaurant on the first floor, a candy store, and the Rambo House Cafe. In the 1920s, room rates were 75¢, $1, and $1.50 per night. In 1951, Norristown had eight registered hotels in the borough, including the Arena's Hotel, Armitage Hotel, Hotel Hamilton, the Lincoln Hotel, the Market House Hotel, Milner Hotel, Valley Forge Hotel, and of course Rambo House Hotel. The Rambo House was demolished in the early 1970s to make way for One Montgomery Plaza. (Historical Society of Montgomery County.)

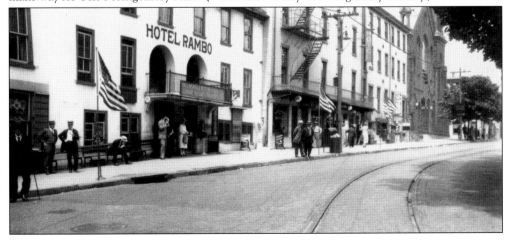

The Ogden House Hotel, complete with a restaurant and saloon, was located on the 200 block of East Main Street, known as Egypt Street in the 1880s when this photograph was taken. Norristown was a major river port more than 125 years ago, and hotels and general stores were a big part of Main Street. In 1880, the borough had 18 hotels and 18 churches. (Historical Society of Montgomery County.)

The Swallow's Hotel, on the right of the photograph, was located on the corner of Main and Green Streets. In the center of the photograph is Kohn's house, and on the left is Isett's house. In 1885, Norristown had 18 registered hotels and as more and more travelers passed through the borough. The need for hotels and eating taverns became more in demand. While many of the travelers arrived by train or boat, a good many of the travelers still came by horse and wagon, which was evidenced by the town's 13 blacksmiths. (Historical Society of Montgomery County.)

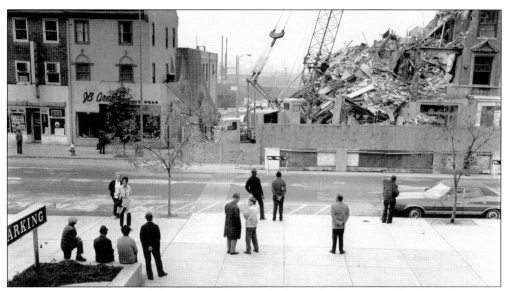

Spectators watch as one of Norristown's landmarks bites the dust in 1974. The Valley Forge Hotel came tumbling down after a long and rich history with the borough. The hotel, located on East Main Street along side Strawberry Alley, was built in 1925 with 80 rooms. The modern-day structure replaced the old Montgomery House Hotel that was built before 1900. Over the years, many prominent people were guests at the hotel, including a visit from Sen. John F. Kennedy on October 29, 1961, and an overnight stay by Amelia Earhart in March 1936. (Historical Society of Montgomery County.)

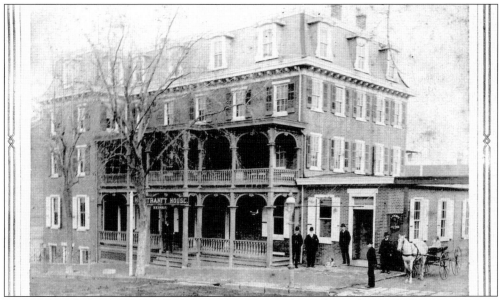

The Hartranft House, later called the Hartranft Hotel, was located at 245 West Main Street. The rooming house was built in the early 1850s and was owned by Joseph Beerer from 1857 to 1872. Percival Kemmerer Gable, standing on the front steps, managed the Hartranft until he took a job managing the Rambo House Hotel located on Swede Street. The Hartranft Hotel continued through 1925, then became the Hotel Norristown from 1927 through 1935, then it became the Milner Hotel from 1935 to 1959, when it was demolished. (The Yost family.)

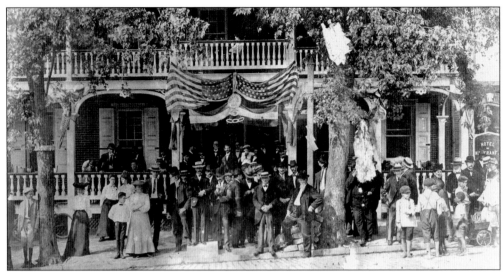

A charitable group of men known as the Odd Fellows established themselves in Montgomery County in 1837, and called Norristown home. The Odd Fellows met in different halls around town until the construction of their very own lodge in 1904. They gathered in front of the old Hartranft House Hotel, once located on West Main Street. The Odd Fellows gathered following a banquet at the Hartranft in honor of the laying of a cornerstone at 230 West Main Street to the new Odd Fellow Temple just across the street from the hotel. This photograph was taken on July 30, 1904, and the building at 230 West Main Street that bears the Odd Fellows name at the top of the building is currently the Cycle Stop.

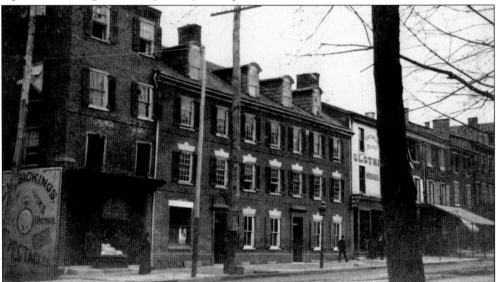

This 1895 photograph shows Bickings Jewelry Store on the left; Bickings was located on the corner of Main Street and Strawberry Alley. The Montgomery House, seen in the center of the photograph, was located at 20 East Main Street. The Montgomery House was demolished in 1924 to make way for the Valley Forge Hotel. Hotels were a common site in the early 20th century in Norristown. A number of the borough's 20 hotels were located on Main Street, including the Hotel Montgomery, the Central Hotel, and A .G. Tyson's French Roof Hotel. Notice the old gas lamp in front of the Montgomery House. (Historical Society of Montgomery County.)

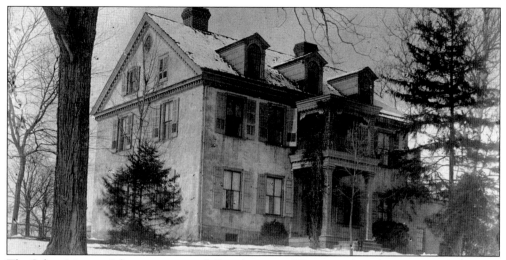

The Selma Mansion's history starts with Revolutionary War general Andrew Porter, who in 1770 purchased 155 acres of property and, in 1794, built the mansion now known as Selma. In 1821, Andrew Knox purchased the estate and his wife, Rebecca, named it Selma after a Scottish poet named Ossian had written about a Selma in one of his poems. Porter had three sons born in the mansion. David Rittenhouse Porter became the ninth governor of the state of Pennsylvania; James Porter cofounded Lafayette Collage and served as a secretary of war under Pres. John Tyler; and George Porter became a governor of Michigan. The Norristown Preservation Society has recently purchased the property and is currently making plans to restore and rebuild the mansion. (Historical Society of Montgomery County.)

A tree-lined dirt road known as Dekalb Street made for a nice residential setting for Dr. H. H. Drake and his family in the 1880s. In the mid-1880s, a horse-drawn trolley line was the only public transportation available and the 70-year-old borough was growing at a rapid rate that included 18 hotels and 18 churches. This building located at 412 Dekalb Street is the current office of Styer and Associates Incorporated Architectural Planners.

Workers are seen here working on the construction of the Yost House located at 1820 Dekalb Street, in October 1924. A building boom was on not only in Norristown but across the country. Calvin Coolidge was reelected as president of the United States in 1924 and ran on a platform of "Coolidge Prosperity." The president promoted business policies, and those policies helped businesses throughout the borough of Norristown. Dan Yost and his wife, Helen, owned and operated a very successful business located at Main and Dekalb Streets. (The Yost family.)

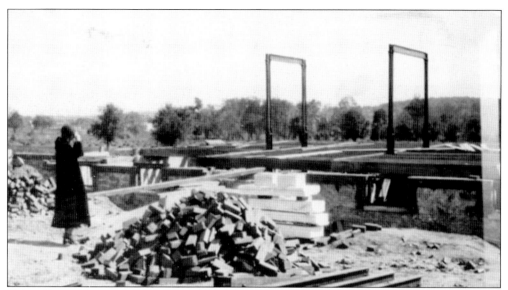

Helen Howie Yost, wife of Dan Yost, is seen here taking pictures of her house located at 1820 Dekalb Street, while under construction in October 1924. Dan and Helen owned and operated a very successful business located on the corner of Main and Dekalb Streets. When the Yosts moved into their house in early 1925, business at the D. M. Yost Company was booming. Norristown's population in the mid-1920s was nearly 35,000 residents, the average cost of a new house was $7,720, a new car was $265. The house at 1820 Dekalb Street was built by Kenneth Howie, and the house is still owned by members of the Yost family. (The Yost family.)

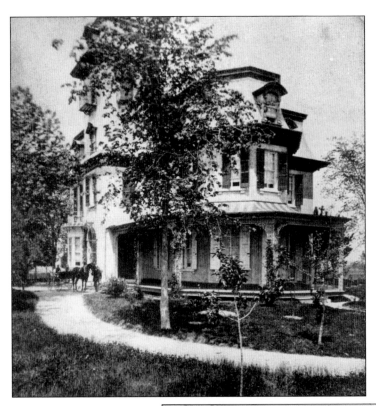

Norristown was very prosperous in the early 20th century, the borough's population continued to grow as the demand for workers in the industrial community increased. With this came the demand for housing, and hundreds of the borough's leading citizens built homes like this one once located on the east corner of Oak and High Streets. Residents that lived at this house included General Butler, John T. Dyer, and Mr. Porter.

This former four-story house built around 1900 is located at the southwesterly corner of Swede and Marshall Streets, 545 and 547 Swede Street. The house was later turned into apartments, and later yet business offices. The building may be unrecognizable today, as the fourth story and the fire escape have been removed. This 1920s photograph details a lot of the marble stonework around the doors and windows that still remain today. (Joe Basile.)

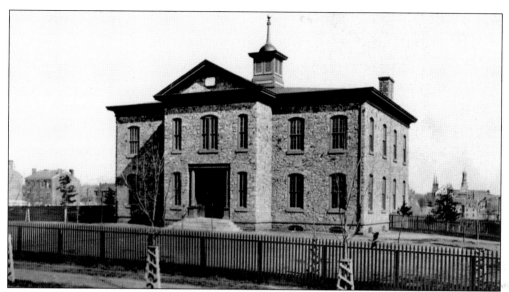

In 1871, the Chain Street School, located on Chain Street between George and Airy Streets, was opened. The building was designed by J. C. Middleton, and the building contained a conference room where the school board of directors would meet. The Hartranft School was built adjacent to the Chain Street School, and the buildings were connected by an underground passage that would allow students to travel from school to school without leaving the buildings. Children in grades 1–4 attended the Chain Street School, and children in grades 5–8 attended the Hartranft School. The Chain Street School was demolished in 1950.

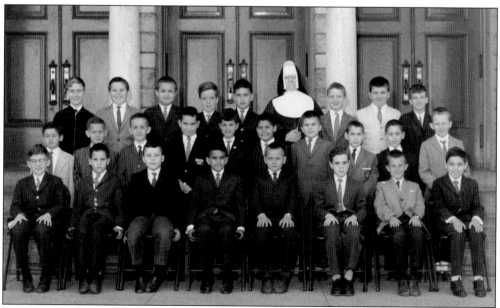

Sr. Francine Marie stands in the back of this photograph showing third- and fourth-grade students at St. Patrick's School in Norristown. When this photograph was taken in 1963, Norristown had 12 public schools and four parochial schools. In 1963, Norristown had 553 retail trade shops within the borough limits. The borough also had 22 crossing guards to help students get safely to and from school.

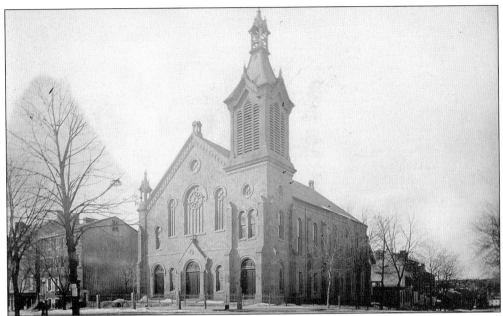

Members of the First Baptist Faith began meeting at the county courthouse as early as 1830 and built their own church on the corner of Swede and Airy Streets in 1833. Forty years later, in 1873, the Baptists constructed what was called the finest-looking church in the borough of Norristown. This photograph was taken in the late 1870s, long before trolley tracks were laid or the streets were paved. This church was demolished in 1972 to make way for One Montgomery Plaza.

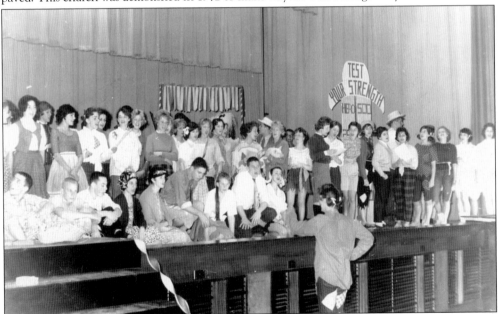

This 1961 photograph shows members of the junior class of Norristown High School participating in an assembly in the school's auditorium. In 1836, the borough established a school system when the Common School Law went into effect. The first two public schools in Norristown were the Church Street School and the Mill Street School. The Mill Street School, located at Mill and Lafayette Streets, was for boys only.

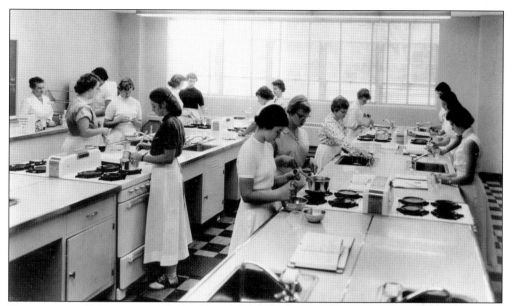

Future nurses of Montgomery Hospital learn the skill of proper diets at McShea Hall in September 1954. Charity Hospital, later renamed Montgomery Hospital, opened in January 1891, and just two years later, a professional nursing school opened. At that time nurses needed two years to graduate, by 1905 the curriculum increased and future nurses needed three years to graduate. After more than 70 years and producing more than 1,100 nurses, the school closed in November 1975. (Historical Society of Montgomery County.)

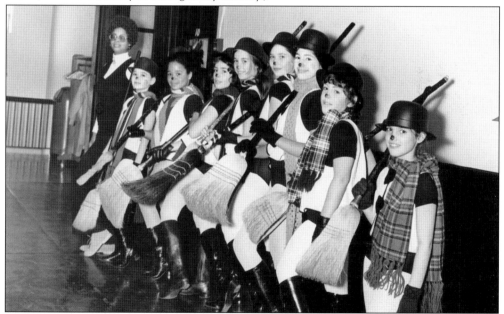

Students from the Roosevelt School on Markley Street performed a Christmas play in the 1960s. The school was built in 1915, and named the Markley Street School. In 1921, the school was renamed the Theodore Roosevelt School in honor of the former president of the United States. Many alterations have been made to the building over the years, and the building still serves as a Norristown school today. (Hank Cisco.)

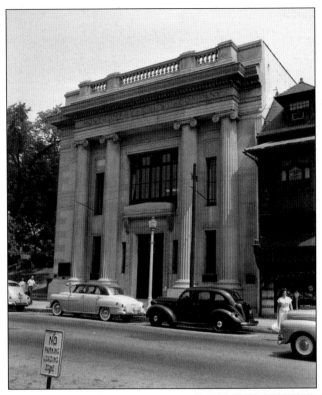

The Montgomery Trust Company was chartered on April 24, 1884, under the name Montgomery Insurance, Trust and Safe Deposit Company and was the first trust company in the county. In 1904, the bank changed its name to the Montgomery Trust Company. In 1912, Montgomery Trust Company bought the Smith and Yocum Hardware store located on Lot 1, east of the public square on Main Street. The former building was demolished, and this handsome structure replaced the old building. The new bank building was open for business on Saturday, November 21, 1914. The Montgomery Trust Building was demolished in the late 1960s along with several other buildings to make way for a multimillion-dollar courthouse expansion and parking garage. (Bill Landis.)

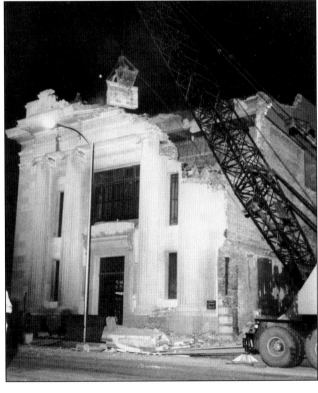

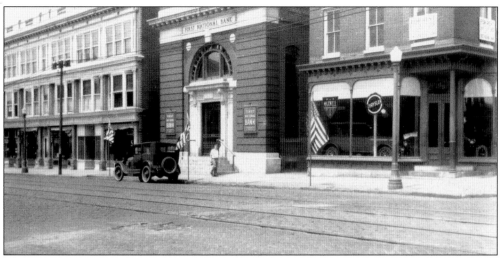

The First National Bank, seen here in the early 1930s, was located near the corner of Main and Cherry Streets. The Norristown bank was the first National Bank in Montgomery County and was chartered on February 23, 1864. Over the next 15 years, 10 more national banks were chartered in the county. In the 1920s, the banking business was booming as 15 new banks were formed in the county between 1920 and 1928. While that was happening, a number of established banks merged with other banks in an effort to make them stronger lending institutions. (Historical Society of Montgomery County.)

Norristown was incorporated in 1812, and two years later, in 1814, the Bank of Montgomery County established itself in Norristown and was the only bank in Montgomery County until 1857. In the 1950s, North Wales National Bank and the Norristown Penn Trust Company merged with Montgomery Trust Company and became Montgomery Norristown Bank and Trust Company with a location on the 200 block of Main Street. (Historical Society of Montgomery County.)

On May 1, 1968, an $11 million expansion project began at the Montgomery County Courthouse that involved knocking down private homes, stores, and banks to make way for an additional 100,000 square feet, nearly doubling the size of the courthouse. In the upper photograph, early demolition can be seen next to the first Norristown borough hall, on the right of the photograph. The town's first borough hall was constructed in 1884. Notice the Valley Forge Hotel in the background. The photograph on the right shows extensive construction where the five-level parking garage now sits, with 415 spaces. (Bill Landis.)

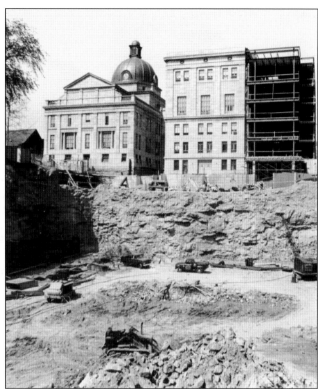

In 1968, a three-and-a-half-year project that cost county taxpayers $11 million began to increase the county courthouse from 129,000 square feet to 229,000 square feet and added a five-tier parking lot with 415 parking spaces. In the upper photograph, construction can been seen where six courtrooms were added to the annex, and the photograph to the left shows construction of the parking garage. In 1980, two more courtrooms were added on the fifth floor. (Bill Landis.)

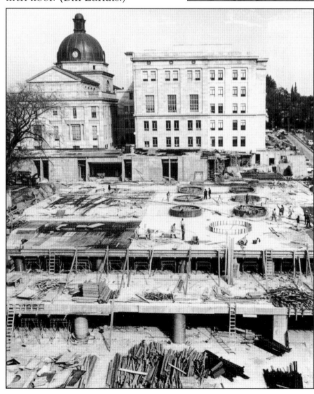

The Norristown Library was incorporated in 1796 and is currently the oldest ongoing establishment in the borough. In 1860, the library moved into a new building located at 516 Dekalb Street By the early 1950s, the library had outgrown the building and in 1953 opened a West End Branch of the library, located in a house at 621 Haws Avenue (above). During this same time period, the library moved to 542 Dekalb Street for more space in a former church. A new library building located at Elm and Swede Streets was dedicated on March 13, 1977. (Bill Landis.)

In 1950, the Norristown Public Library was located at 516 Dekalb Street. The Norristown Library was incorporated in 1796; the first library building was built on Main Street at a cost of $153.43 and remained on Main Street until 1853. The library was housed in a building on the northwest corner of Dekalb and Penn Streets until 1860 before moving into a new building, shown in the photograph, in 1860. By the mid-1950s, the library had outgrown this building, and in 1977, it moved to its current location at Elm and Swede Streets. The building in the photograph still stands with the white stone over the doorway that reads "Library 1859." (Bill Landis.)

An organization called Hello Columbus Monument was formed in December 1984, with the purpose of designing, funding, and building a monument to honor Christopher Columbus. Ground was donated by the county next to the Elmwood Park Zoo, for the purpose of the monument. Eight years later, the $400,000 project was dedicated on October 12, 1992. In the photograph to the right, honorary chairman Tommy Lasorda (left), then manager of the Los Angeles Dodgers, chats with Montgomery County commissioner Mario Meli, a member of the board of directors for the Columbus monument. In the lower photograph, other members of the board of directors talk at the construction site, including, from left to right, Frank Petrone, a member of the building committee; Norristown mayor Bill DeAngelis; Hank Cisco, general chairman of the project; and Tony Delucia, chairman of the building committee. (Hank Cisco.)

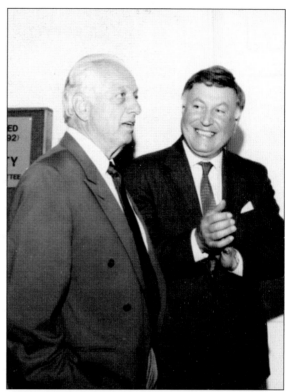

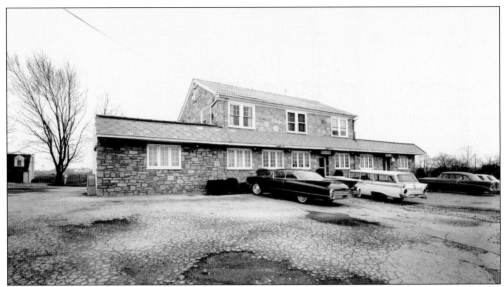

Jules Lambardi's tavern was located on Ridge Pike and in the 1960s was one of the finest dining spots in Montgomery County. In the early 1960s, there were nearly 2,000 restaurants in Montgomery County. Lambardi's was hurt like many other dining establishments in the 1960s with the continued growth of fast food restaurants chains. A car dealer has long since replaced Lambardi's. (Historical Society of Montgomery County.)

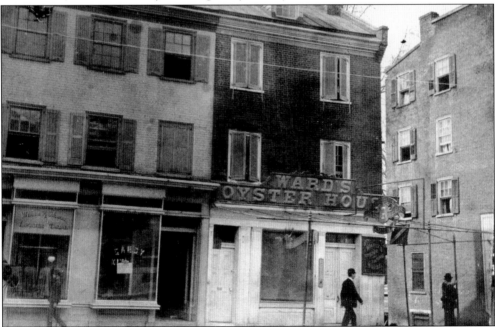

Ward's Oyster House, owned by B. T. Ward, was located on East Main Street alongside Strawberry Alley. Ward's was a popular eating establishment in the late 1890s and early part of the next century. The side of the old Montgomery Hotel building can be seen on the right; the old Montgomery stables were located behind the hotel. In 1895, the borough had 16 restaurants and 20 hotels. Most of the hotels had restaurants and saloons in the same building. (Historical Society of Montgomery County.)

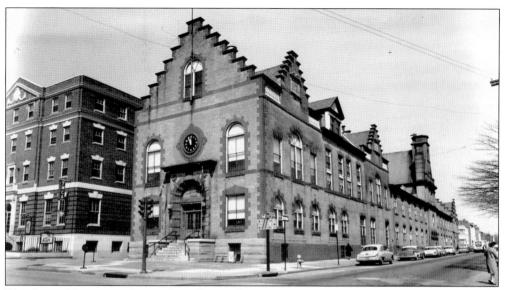

The former Norristown Borough Hall, once located on the corner of Dekalb and Airy Streets, not only housed government offices but the Norristown Police Department as well. The two-story structure was built on the site of the old borough market in 1896, and the new building for many years had market stalls along Dekalb Street where vendors continued to make a living for many years after. By the 1960s, the building started to deteriorate beyond repair, and in 1974, the borough moved into new offices located on the north side of Airy Street, a stone's throw from the old borough offices. (Bill Landis.)

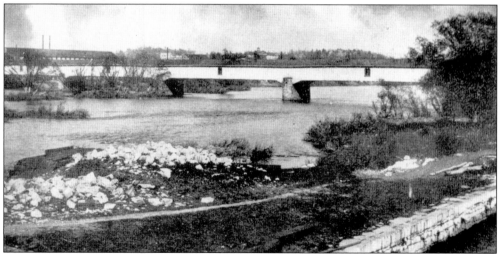

The Norristown Covered Bridge spanning the Schuylkill River from Bridgeport going east to Norristown was originally built in 1829 at a cost of $31,200. The bridge began taking tolls on January 9, 1830. In 1830, the borough contained 1,089 residents. Over the next half century, Norristown's population swelled to nearly 14,000 residents, and by May 1883, the borough contained 281 licensed retailers and dealers with 29 hotels, 13 restaurants, eight liquor stores, and two breweries. Residents from Bridgeport and Upper Merion Township put pressure on the county leaders for a public bridge that would be free to cross, and after a long and hard-fought struggle the residents were declared free from tolls on October 13, 1884. (Historical Society of Montgomery County.)

ACROSS AMERICA, PEOPLE ARE DISCOVERING SOMETHING WONDERFUL. *THEIR HERITAGE.*

Arcadia Publishing is the leading local history publisher in the United States. With more than 3,000 titles in print and hundreds of new titles released every year, Arcadia has extensive specialized experience chronicling the history of communities and celebrating America's hidden stories, bringing to life the people, places, and events from the past. To discover the history of other communities across the nation, please visit:

www.arcadiapublishing.com

Customized search tools allow you to find regional history books about the town where you grew up, the cities where your friends and family live, the town where your parents met, or even that retirement spot you've been dreaming about.